Prints at the Essex Institute

by Bettina A. Norton

Essex Institute
Salem, Massachusetts

R Thayer

Photographs by R. Jackson Smith

Essex Institute
Museum Booklet Series

© Copyright 1978 by the Essex Institute
Salem, Massachusetts 01970

All Rights Reserved

Library of Congress Cataloging and Publication Data
ISBN 0-88389-069-0 78-19448

Designed by Hiestand Design Associates
Printed at Woodland Publishing Company
Additional Photography by Mark Sexton

Publication expenses have been generously
supported by a grant from the National
Endowment for the Arts and the Alfred E. Chase
Charity Foundation of Boston.

This project is supported by a grant from the
National Endowment for the Arts in Washington,
D.C., a Federal Agency and the Alfred E. Chase
Charity Foundation of Boston.

Foreword

The print collections of early established New England historical societies tend to be exceedingly rich in their descriptions of the region's history and topography. The collection at the Essex Institute (founded in 1821 as the Essex Historical Society) is no exception. Several thousand prints, with all mediums well represented, have been collected and kept—at first by Essex County residents and later by the Institute—for their artistic and historical interest, for their description of famous people or events, for their record of the local and national landscape, and often simply for their humor or their biting satire. The print collection of the Essex Institute spans the early eighteenth century to the mid-twentieth century, offering valuable perceptions into Essex County and American life.

Over the past two years we have been fortunate in having on our staff Bettina A. Norton, a specialist in American historical prints, who has worked on cataloging and conserving our collection. This special project was funded by a grant from the National Endowment for the Arts which was matched by the Massachusetts Council on the Arts and Humanities, private donors, and the Essex Institute. During her assignment, Mrs. Norton has painstakingly identified much previously uncatalogued material, has done research and updated information on the entire collection, and has written this excellent booklet as a representative summary of our collection of prints. The second booklet to appear in our museum booklet series, it is both a contribution to scholarship and a joy to read. Our sincere appreciation goes to the author for her fine text, to R. Jackson Smith for his handsome photographs, and to Katherine W. Richardson of the Institute staff for her meticulous copy editing.

We are particularly indebted to the National Endowment for the Arts which provided funds for the publication of this booklet as the final step in our cataloging project. Matching funds for this portion of the project were generously made available by the Alfred E. Chase Charity Foundation of Boston, and the Institute. Museum collections must be properly catalogued and published to ensure that the public is aware of their contents and potential uses as educational resources. We are grateful for the financial assistance which has allowed us to accomplish this task for one of our most interesting collections—our prints.

Anne Farnam, *Curator*
Bryant F. Tolles, Jr., *Director*

Prints at the Essex Institute

The print collection of the Essex Institute, like that of other well-based New England historical societies and libraries, has expected strengths and predictable examples. Yet the collection also has a surprising and unusual accumulation of prints in several fields which give important insights into Essex County's former inhabitants—their diversions, passions, worries, and delights. The predictable holdings include prints of local topographical scenes—city and town views, buildings, factories; American portraits—military and political figures, clergy, successful local merchants, and visiting performers; certificates; historical and political prints; and genre.

The several pleasant surprises revealed in the recent cataloging of the collection include a large number of European prints, often in portfolios compiled by Salem residents at home and abroad; an impressive holding of views of American cities and towns; a number of additions to the collection of railroad and transportation prints; over two hundred late nineteenth century theater prints and posters, many of which have added labels giving performance dates at Salem's Mechanic Hall; and posters for turn-of-the-century literary publications drawn by such figures as Edward Penfield, Louis Rhead, and Will Bradley.

Eighteenth and early-nineteenth-century American printmakers, both nationally known and less familiar, are represented, as are many different techniques of printmaking (described in the appendix, page 59). The Institute owns a few prints by Paul Revere, and a number of original mezzotint portraits of mid-eighteenth-century divines by Peter Pelham of Boston. Other early Boston printmakers include Thomas Johnston, J. R. Smith, Samuel Hill. Early Philadelphia engravers are represented by such figures as Edward Savage, John J. Barralet, and Cornelius Tiebout. The New York contingent includes John Hill and Asher Durand. As each major city increased its production, however, collections such as that here at the Institute began to focus on prints produced in their own area.

Among the many lithographic artists in Boston firms whose works are in the Institute are Rembrandt Peale, John Henry Bufford, James Kidder, William Sharp,

Joseph E. Baker, and two nationally known figures with Essex County associations—Fitz Hugh Lane and Winslow Homer. The collection contains examples from most of the professional printmakers whose work was printed locally or in the nearby publishing center of Boston.

Over the years, the Institute has also amassed examples of local residents who tried their hand at whatever medium was fashionable at the time—Samuel Blyth, who made some mezzotint portraits of military figures of the Revolution; young ladies like Mary Jane Derby and other students at Salem's academies, who drew pleasant views of Salem; and the late-nineteenth-century adherents of the contemporary Etching Revival, like H. Frances Osborne and George Merwanjee White. Frank Benson became known as the "dean of American etchers." Later, Samuel Chamberlain, renowned photographer as well as etcher, kept alive the interest in classical printmaking techniques in Essex County with the formation in 1940 of the Friends of Contemporary Prints at the Marblehead Arts Association.

The prints in the Institute also naturally reflect the interests and collecting habits of its donors. The Reverend William Bentley, Salem's well-known and often-quoted diarist, wrote to himself in 1803, "I promised Turell to assist . . . his useful purpose of assisting himself by promoting good taste & useful knowledge in our Country. He recommended a new shop of prints near the old Court House [in Boston] opened by an Italian, lately from New York, which I did not see."[1]

George Merwanjee White collected a large number of fine European etchings and engravings from the seventeenth and eighteenth centuries. John Robinson, his contemporary and a curator at the Institute, gave over a period of years more than two thousand prints, photographs, and drawings (some by his own hand), primarily American. The collection was already substantial when Sylvester Rosa Koehler, curator of prints at the Museum of Fine Arts in Boston, described the Essex Institute for *The United States Art Directory* of 1884, noting the "many rare and choice engravings and prints."[2]

These early gifts formed the nucleus of the collection. In the 1920s, Frederick Boardman Crowninshield Bradlee added a large number of transportation prints and ephemera, especially on railroads. Other generous donors have continuously aided the Institute's goal of acquiring prints related to Essex County—by subject, artist, place of publication, or provenance.

The Essex Institute is fortunate to have not only a museum, but also six fine historic houses in which prints can be displayed. In the houses—the John Ward (1684), the Crowninshield-Bentley (1727), the Assembly (1782), the Peirce-Nichols (1782), the Gardner-Pingree (1804), and the Andrew-Safford (1818)—hang prints which well might have been in the homes when they were first occupied by Salem families. In the museum itself, temporary exhibitions constantly use the prints in the collection to enhance a theme, and occasionally a show of prints alone is mounted to illustrate some facet of Essex County life.

The discussion of the print collection which follows is in three sections. The first is a brief summary of the various categories in the collection, with illustrated examples. The second section deals extensively with prints as they were used in Essex County homes up to the end of the Federal period and as they are now displayed in the Institute's historic houses. The third section discusses the story of Salem and other Essex County printmakers as it has been revealed through a study of the collection.

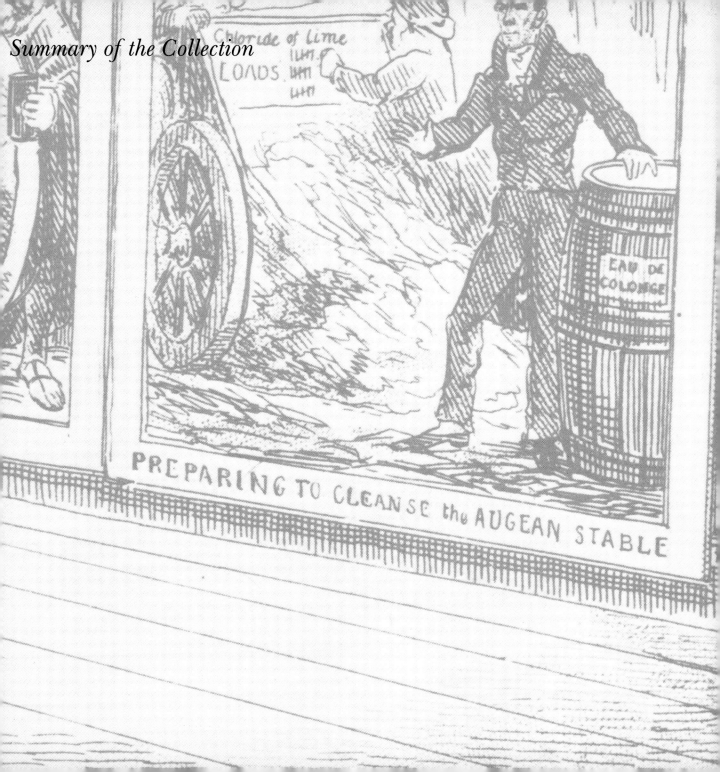

PREPARING TO CLEANSE the AUGEAN STABLE

Town views and landscapes

One of the earliest and still most important prints in the Essex Institute collections is *A North-East View of the Town of Boston,* given by Thomas Prince in 1850 *(fig. 1).* The engraving, widely attributed to be after a drawing by William Burgis first offered for sale in 1722, is a unique impression. Still unknown is by whom or where it was engraved.[3] Burgis drew another larger view of Boston from the southeast, the first edition of which was printed and published in 1725.

The collection of town and city views in the Institute is surprisingly large. It reflects not only an attempt to catalog the known views of Essex County towns, but the economic interests of its residents, as a number of western towns depicted are those in which some Essex County money was probably invested, like *Todd's Valley, California,* and *Dubuque, Iowa. 1870, (fig. 2).*

Early views include aquatints by John Hill for *Picturesque Views of American Scenery* and the *Hudson River*

1. *A North-East View of the Great Town of Boston,* possibly 1723. Engraving, attributed to William Burgis, printer unknown; 17.2 x 31.6 cm. (Measurements are given for image only, except where noted.) (Accession number: 1,163).

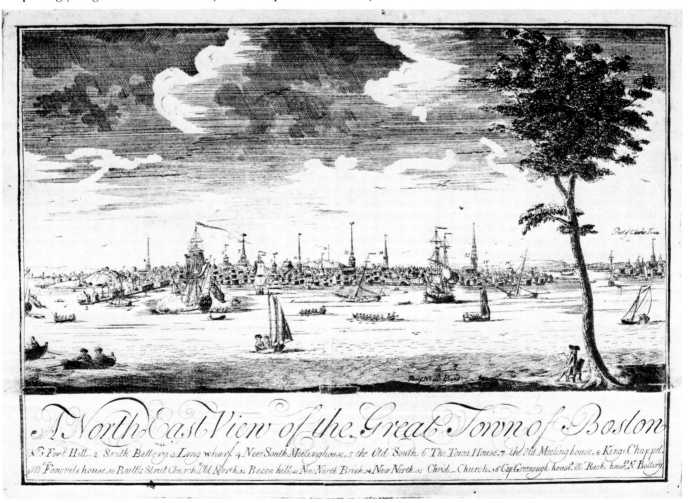

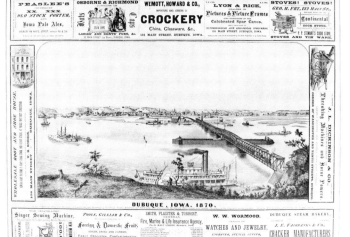

Portfolio, published in the 1820s, and views of Niagara, both foreign and domestic. Later views include most of the plates from John B. Bachelder's *Album of New England Scenery,* which includes a number of Essex County towns; a set of views of Cincinnati, and the only complete set in an east coast collection of Edwin Whitefield's seven views of Chicago before the fire of 1871.

Whitefield drew and generally put on stone himself over sixty views of towns and cities in the northeastern United States and Canada. The Institute owns eight, of which four are in Essex County—Beverly, Danvers, Lynn, and Salem. The Salem view was issued in two versions; here illustrated is the first and larger one[4] *(fig. 3)*.

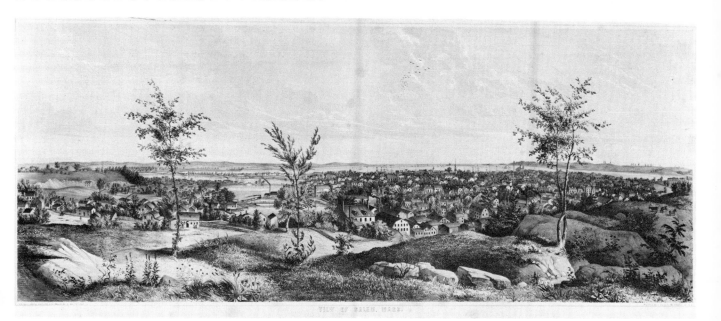

2. *Dubuque, Iowa. 1870.*
Tinted lithograph, printed by the Chicago Lithographing Company, Chicago; 31.2 x 56 cm. (1,759).

3. *View of Salem, Mass.,*
1849. Tinted lithograph by Edwin Whitefield and printed by Francis Michelin, New York; 38 x 97.8 cm. (4,384).

Commercial buildings

The collection contains most of the known prints of Essex County businesses, beginning with the earliest, a stock certificate for the *Salem Iron Factory* in Danvers, printed around 1800 *(fig. 4),* and the Wolfe Tavern in Newburyport, printed around 1805. Other early views appeared on letterheads and ream wrappers, such as a view of the riverside paper factory of F. Peabody and Company in Salem.

With the increased use of color lithography, larger printing stones, and larger shops in which to print them, advertisements became more flamboyant. Though generally common, these chromolithographs issued in the last half of the nineteenth century are among the most enjoyed images of this and most collections.

The *Salem Lead Company,* lithographed by the Charles H. Crosby Company of Boston around 1869, is shown in two views, front and side *(fig. 5).* Located on the shore of the North River in Salem and connected to the rail system of the Essex County Rail Road, the company had two handy methods of dispersing its goods, both illustrated in their advertising print. A rival firm, the Forest River White and Sheet Lead Works, also issued a chromolithograph advertisement from the Boston shop of F. F. Oakley.

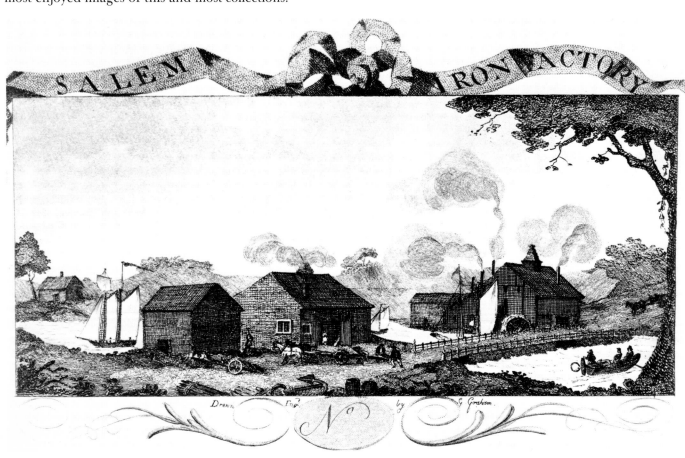

4. *Salem Iron Factory,*
ca. 1800. Etching, aquatint, and stipple by George Graham, Boston; 9.7 x 16.7 cm. (134,443).

5. *Salem Lead Company,*
ca. 1869. Chromolithograph by D. Drummond and printed by Charles H. Crosby and Company, Boston; 56 x 71.8 cm. (115,669).

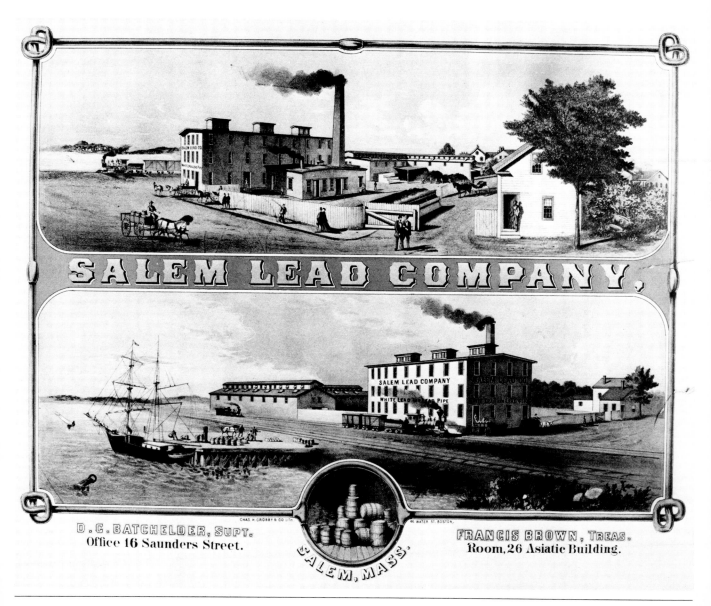

Buildings

In the mid-eighteenth century a few French Catholics from Arcadia settled in Salem, but it was about one hundred years later that French Canadians began to come in large numbers. Most found employment in the Naumkeag Steam and Cotton Mill and populated an area soon called "La Pointe." The parish of St. Joseph was founded in 1873 to serve these new residents of Salem. The church of St. Joseph was opened for worship in 1884, and, under the guidance of its sixth rector, the Reverend Joseph A. Gadoury, the school was added in 1892 (*fig. 6*).[5]

Around the end of the nineteenth century, a great deal of interest arose in relics of America's past. Brought on by the Centennial, the search focused on such obvious landmarks as early colonial houses. Amateur historians eager to establish antiquarianism often dated buildings by when they first appeared on a site, not taking into account that an earlier house may have disappeared through fire, neglect, or ambitious rebuilding at some past and forgotten time, as the race was on to determine the oldest standing house in New England.

One print, issued around 1876, set forth that claim. But some past owner of the print, with New England truculence, denied the fact in the simplest way possible—by writing NOT in front of the title (*fig. 7*). The sour expression on the face of the rider in the foreground seems to suggest that he agrees.

The old Bakery, Salem (fig. 8) later became the first house property owned by the Essex Institute, and one of the earliest examples of historic restoration by an institution in America. Moved from St. Peter Street in 1910 to its present location behind the museum, the house was promptly restored to its older structural shape and assumed the name of its original owner, John Ward.

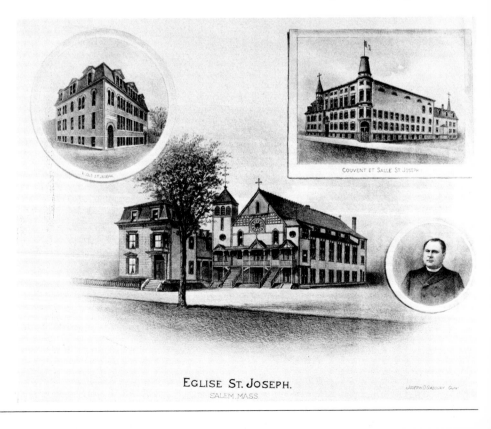

EGLISE ST. JOSEPH.
SALEM, MASS

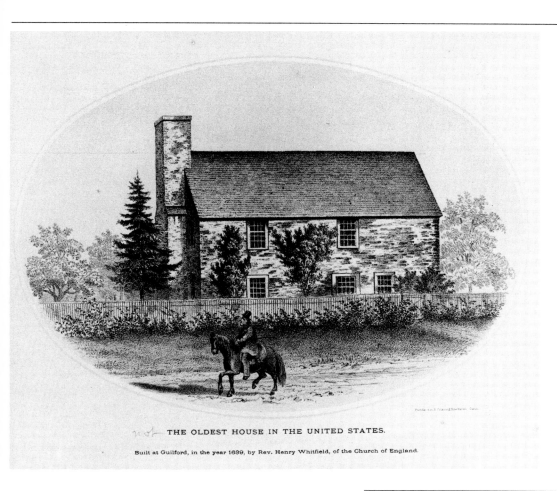

THE OLDEST HOUSE IN THE UNITED STATES.

Built at Guilford, in the year 1639, by Rev. Henry Whitfield, of the Church of England.

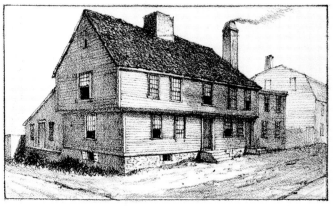

The old Bakery, Salem.

6. *Eglise St. Joseph,*
ca. 1892. Lithograph on metal plate printed by E. R. Howe, Boston; 43 x 58.5 cm. (115,667).

7. NOT *The Oldest house in the United States,*
ca. 1876. Tinted lithograph printed by Punderson and Crisand, New Haven; 15.5 x 23.3 cm. (134,199).

8. *The old Bakery, Salem,*
1879. Tinted lithograph by Edwin Whitefield in his *The Homes of our Forefathers . . . in Massachusetts,* 3rd. edition (Boston, 1880); 7.4 x 12.7 cm. (728/W59).

Portraits

Fully one third of the images in the collection are portraits, in a great variety of mediums. Most numerous of the European ones are portraits of the English royalty and nobility, especially those figures who had some traffic with the colonists, such as William Pitt, General Wolfe at Quebec, and Admiral Pocock. There is also a superb mezzotint portrait of the Earl of Buchan by John Finlayson, inscribed in pen, "To the Revd. Mr. Pemberton as a mark of my respect for his Character & for the Purity of his Life & Doctrines. I am not asham'd of the Gospel of Xt./ Ubi Libertas Ibi Patria" *(fig. 9)*. Napoleon I, an object of some fascination to Salem residents, is represented in a number of prints, both European and American, on his military exploits, state ceremonies, residences, and exile at St. Helena *(see fig. 40)*.

Among the most important of the early American prints are the mezzotint portraits by Peter Pelham, colonial Boston's most important portrait printmaker. Of the twelve clergymen produced by Pelham, the Institute owns six *(see fig. 26)*. Among the most interesting portraits is that of *Edwardus Holyoke,* limned in mezzotint in 1749; although the printmaker is unidentified, he is believed to have been John Greenwood. Early stipple engravings include portraits of the presidents and early members of Congress published by the Savages of Philadelphia and New York, and a number of prints after portraits by Gilbert Stuart and John Singleton Copley. One of the best portrait prints in the collection is the freely executed mezzotint of Benjamin Thompson, Count Rumford, of Woburn, Massachusetts, by John R. Smith. Most abundant are prints of George Washington, "Father of our Country" *(see fig. 31)*.

Later portrait painters' works disseminated through prints include Ralph Eleazer Whiteside Earl's *Andrew Jackson at the Hermitage,* a large Pendleton lithograph, and Chester Harding's fine portrait of William Ellery Channing engraved by William Hoogland. Prints from New York firms of special interest to Essex County include portraits of the missionary Adoniram Judson holding his Burmese translation of the Bible, and the Reverend Father Mathew, the Apostle of Temperance. A well-executed group portrait of the Mendelssohn

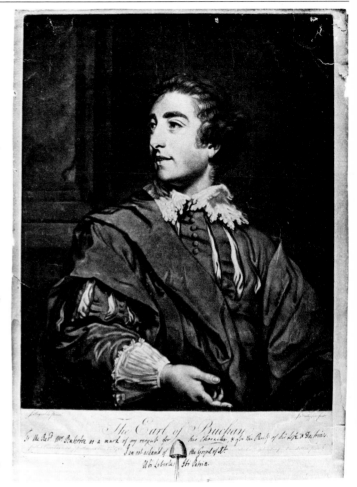

9. *The Earl of Buchan,*
1765. Mezzotint by J. Finlayson after J. Reynolds, London; 34.3 x 27.6 cm. (115,931).

10. *R[obert]. Rantoul Jr.,*
ca. 1853. Lithograph with gold border printed by Tappan and Bradford, Boston; 37 x 31.2 cm. (4320 b).

11. *Voice of the Bells. [Henry] Morgan,*
ca. 1882. Color lithograph printed by J. H. Bufford's Sons, Boston; 61.8 x 50.5 cm. (134,008).

12. *With compliments of Th: Nast, Feb. 4—1885.*
Etching self portrait by Thomas Nast, New York; 15.8 x 11.3 cm. (115,653).

13. *Chas. L. Davis/in his great original character of/"Alvin Joslin,"*
ca. 1885. Chromolithograph printed by Forbes Company, Boston, with attached letterpress label; 60.5 x 50 cm. (134,117).

Quintet Club was probably exhibited in Salem to advertise their concert during the Salem Lyceum's 1853-54 season.

Robert Rantoul was an Essex County man (born in Beverly in 1805) who achieved national importance upon his election in 1851 to the United States Senate to fill the unexpired term of Daniel Webster. Both men died the next year, bringing about the only case in American national politics of two special elections to fill one term of office *(fig. 10)*.

Among the religious revivalists of the late nineteenth century was Henry Morgan, leader of a splinter group of Methodists *(fig. 11)*. Under his influence, four churches in Boston became affiliated with his reform movement. Calling himself "The Voice of the Bells," Morgan advertised his popular lectures in large lithographed posters. In addition to the one illustrated, the Institute owns another, as well as a Biblical scene interpreted liberally and drawn on stone by Morgan. Among the "Seventeen Reasons Why Men Dont Go to Church" are "Back Bay churches of Boston, up in a balloon," "wife has no new bonnet of the period," "Sunday cooks—Parkers—'pit cook against parson, cook beats every time.'"

Thomas Nast (1840-1902) brought to the contemporary revival of etching his own brand of satire. This print is an unexpected treasure in the Institute's collections *(fig. 12)*. Signed "with compliments of Th: Nast Feb. 4—1885," it is regrettable that it is unknown to whom he paid his compliments, or how the print came to the Institute. Possibly Nast gave it to a fellow etcher from Salem, like Frank Benson.

Significant additions to the collection are the more than two hundred newly discovered portrait prints of late-nineteenth-century theatrical performers who appeared in Salem: Charles L. Davis *(fig. 13)*, Miss Lizzie Kelsey, Miss Nilsson, George L. Fox, and others. Used for advertisements, the prints in most cases have an added label giving the time and place of performances, usually Salem's Mechanic Hall.

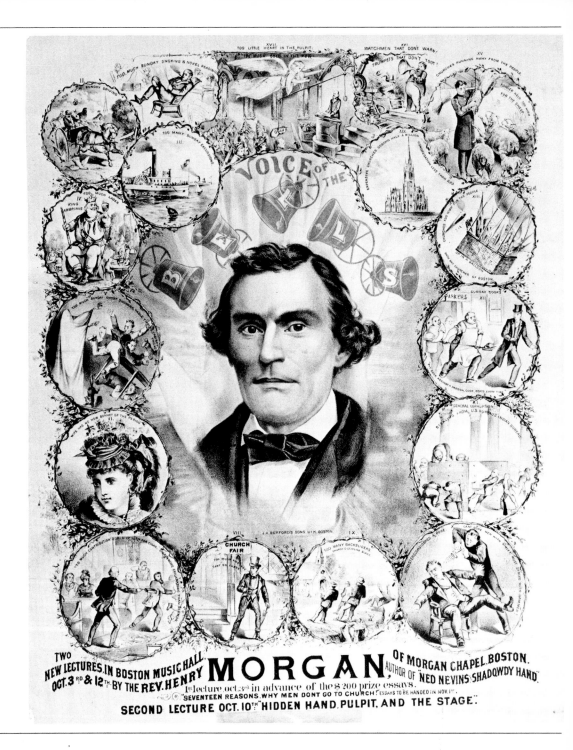

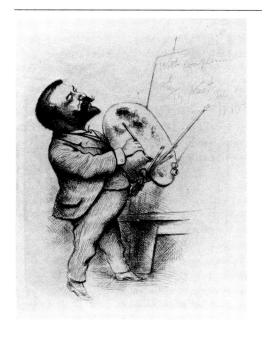

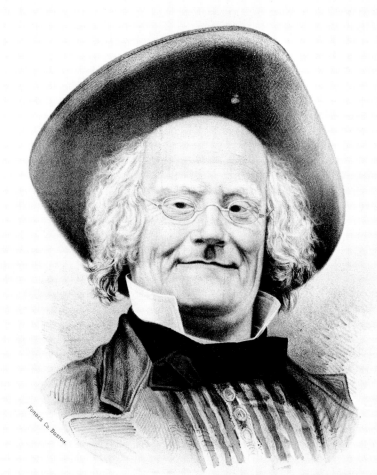

CHAS. L. DAVIS,

IN HIS GREAT ORIGINAL CHARACTER OF

"ALVIN JOSLIN."

MECHANIC HALL. ONE NIGHT ONLY.

TUESDAY EVENING,
Prices as usual.

Dec. 16.

Reserved Seats on Sale at A. A. Smith & Co.'s.

Certificates

Most certificates in the Institute's collection, though they were generally printed in Boston or other major publishing centers, have an identifiable Essex County association—either through the organization itself, or, if a national one, through a local member.

A number of charitable organizations sprang up at the beginning of the nineteenth century to take care of working men and their families, or those less fortunate than themselves. Certificates were issued to their members. The Salem Charitable Mechanic Association held a fair in 1849 and issued an advertising broadside which drew liberally on the membership certificate first printed around 1822 (fig. 14; see also fig. 34). The artist for the fair announcement, William Sharp of Boston, made one noticeable change; in place of the earlier depiction of a printing press he substituted a mother pointing out the virtues of artisanry to her son.

A second type of certificate was issued to members of professional organizations as a testament to their qualifications. The *Massachusetts College of Pharmacy* around 1828 commissioned the Senefelder Lithographic Company to print a certificate from the original "cabinet picture" of James Kidder (fig. 15). His talents as a draftsman were reason enough to use him, but, in addition, his uncle owned one of the most well-known apothecaries in Boston. Gardner Barton, to whom this certificate was issued, ran an apothecary shop in Salem on the present site of the Crowninshield-Bentley House. A recreation of the 1830s Salem apothecary shop of Dr. William Webb has been set up in the Ward House, and the certificate of Barton is there displayed.

The many prints entitled *In Memory* were issued for the families of the deceased. Although lithography was the most common medium for these prints, the example illustrated here is a woodcut, colored by hand. Inscriptions were usually filled in by hand also, but this curious memorial print has the name of the deceased and an additional poem added in letterpress (fig. 16). Presumably more than one impression was made, possibly for some far-flung family members.

Anna Maria McKenzie, who died before she reached her first birthday, was buried from the Tabernacle Church in Salem (see fig. 43). She was the fourth child of Roderick McKenzie, Salem ship master. Two other children, born after Anna died, fell victims of scarlet fever within a day of each other, at the ages of two and four. Still another son, born to the then widowed Mrs. McKenzie, died before he reached his fifth birthday. Such unhappy events explain the abundance of memorial prints in the nineteenth century.

14. *Salem Charitable Mechanic Association/Mechanics' Fair,* 1849. Tinted lithograph by William Sharp, Boston; 64 x 50.3 cm. (whole sheet). (134,098).

15. *The Massachusetts College of Pharmacy,* membership certificate, ca. 1830. Lithograph by James Kidder, printed by Senefelder Lithographic Company, Boston; 26 x 24 cm. (with text). (134,442).

16. *In Memory of* (in pen:) Anna Maria Mckenzie, ca. 1836. Woodcut with added watercolor, printer unknown; 28 x 37 cm. (121,900).

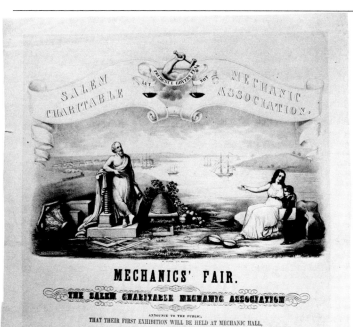

MECHANICS' FAIR.

THE SALEM CHARITABLE MECHANIC ASSOCIATION

ANNOUNCE TO THE PUBLIC,

THAT THEIR FIRST EXHIBITION WILL BE HELD AT MECHANIC HALL,

IN THE CITY OF SALEM,

COMMENCING ON MONDAY, SEPTEMBER 24, 1849,

AND CONTINUING THROUGH THE WEEK.

We invite ALL to contribute in every department of industry, which can in any way promote the comfort, convenience, or improvement of mankind. We respectfully solicit the aid of Mechanics, Manufacturers, and Artists. Let them bring forward the products of the Loom and the Forge. All kinds of Machinery;—every description of Tool and Implement. Articles of Wood, Stone, Metal, Glass, Leather, Wool, Cotton, Silk, Hemp and Flax, specimens of Printing, Statuary, Painting, Daguerreotypes, Engraving and Lithography. Articles of Female ingenuity and taste will have a prominent place in the Exhibition.

The Annual Exhibition of the Essex Agricultural Society, and the Essex Institute, will take place in Salem, during the week of our Fair; we trust that the Manufacturer of Agricultural Implements will bear this in mind, and that we may have a good display of articles in this department.

The Superintendent of the Fair will be entrusted with the care and management of every article sent for exhibition, and every facility will be given to show its useful purpose, its ingenious contrivance. Care will be taken to preserve them from injury; trustworthy men will be in attendance day and night; but all articles will be at the risk of the owners. Each Contributor will be entitled to admission. Contributors are particularly and earnestly requested to send forward their goods in season. Articles intended for exhibition, will be received from the 1st to the 22d September. A check will be given for each article received, which must be presented when they are returned.

All Goods, Machinery, &c., intended for exhibition, will be transported, over the Railroads leading into the city, free of expense.

Medals of Silver, and Diplomas, will be awarded according to the merit of the articles exhibited. Strict justice shall be adjudged to every contributor. Impartial men, possessing intelligence, and competent knowledge in each department of art, will be selected as judges; those only will be appointed who are not competitors for premiums.

☞ All communications in relation to the Fair, should be addressed (post paid) to the Secretary of the Association.

MANAGERS

ALBERT G. BROWNE, President.
THOMAS NICHOLS, Jr., Vice President.
JOHN CHAPMAN, Treasurer.
ELEAZER M. DALTON, Secretary.

WILLIAM SUTTON,
JOHN HUSE,
ALVAH KENDALL,
JOHN PICKERING, 3d.

ABRAHAM TOWLE,
EDWARD CURRIER,
BENJAMIN COX,
STEPHEN WHITMORE, Jr.

AMOS F. DAY,
BENJAMIN EDWARDS,
STRATTON W. ROBERTSON.

NATHANIEL VERY, Jr., Superintendent.

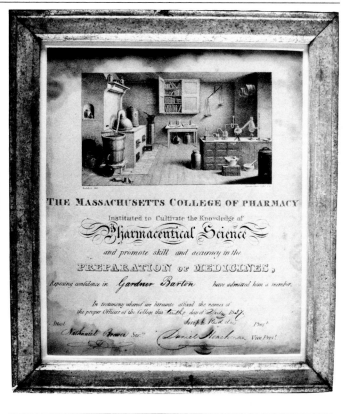

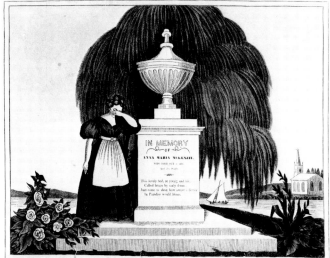

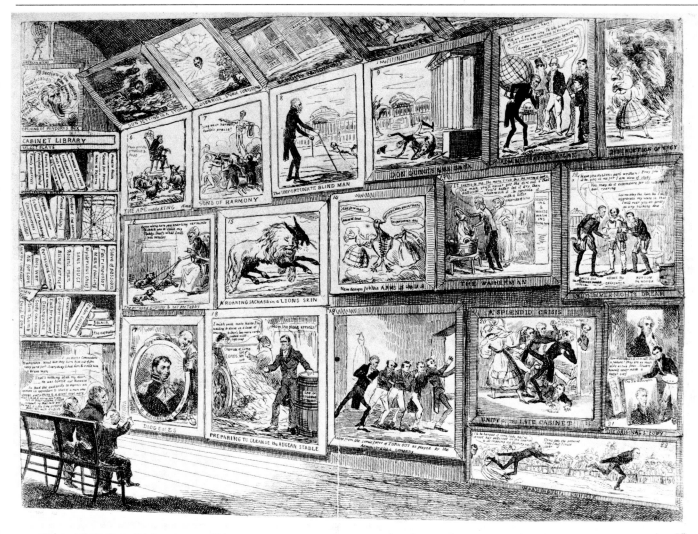

EXHIBITION OF CABINET PICTURES

Political prints

The Institute is known for its excellent collection of political prints, collected primarily by a former director, George Francis Dow. They comprise late-eighteenth and nineteenth-century English and American prints. The latter cover events of national significance from the Revolution through the Civil War, with a few more recent graphic comments on Essex County politics. The question of slavery and Andrew Jackson's policies are well represented, and are further enriched by two additions to the collection in the past year.

Exhibition of Cabinet Pictures (fig. 17) was etched in 1829 or 1830 by "Snooks," one of several pseudonyms of one of America's best nineteenth-century graphic humorists, David Claypoole Johnston (1799-1865). In one of the "cabinet pictures" (second from the bottom at the right) is his self-portrait. Andrew Jackson is attacked in all the pictures, on the book titles, and by the group of viewers in the foreground. At the top right, four men observe Jackson with a globe upon his back; one says "It would be very tiresome to support the Globe all day—does he do it for a living?" To which another replies, "No. The Globe supports him for a living." Another "picture" depicts the nose- and hair-pulling fisticuff and is entitled "Unity of the Late Cabinet." This print, like many by Johnston and the English school of satire from which he descended, demands a careful reading.

In 1850 Congress approved the compromises on the question of the extension of slavery into the new territories and passed the Fugitive Slave Act. The prestige of Daniel Webster, senator from Massachusetts, who advocated both, thereupon fell in the eyes of his constituents. He felt that compromise was necessary for the all-important preservation of the Union, "to beat down the Northern and Southern follies," as he termed the extremists; he based his arguments on the fact that slavery was not prohibited by the Constitution.

Northern partisans of abolition were horrified. This cartoon, *Conquering Prejudice or "fulfilling a Constitutional duty with alacrity" (fig. 18)* was printed soon after Webster's speech was published. The text was used for the title and—freely rendered—for the other quote of Webster. The little country church behind the fleeing woman and the typical court house behind Webster are intended symbolism.

17. *Exhibition of Cabinet Pictures,* ca. 1830. Etching by David Claypoole Johnston, Boston; 20.1 x 27.9 cm. (133,883).

18. *'Conquering Prejudice,'/ or/"Fulfilling a Constitutional Duty with Alacrity,"* 1850. Lithograph by Peter Kramer printed by P. S. Duval's Steam Lith. Press, Philadelphia; 22.3 x 30.5 cm. (133,944).

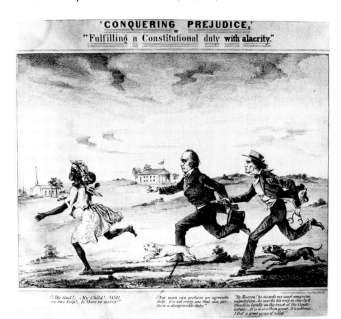

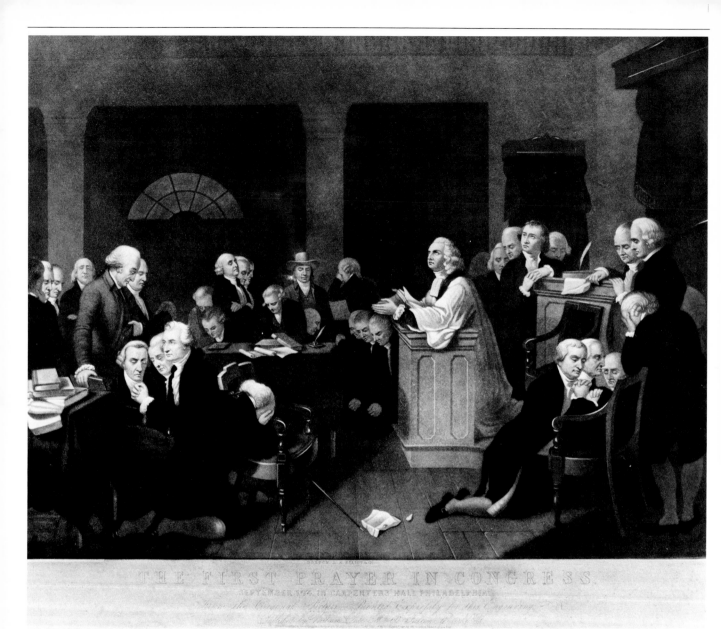

THE FIRST PRAYER IN CONGRESS.
SEPTEMBER 1774, IN CARPENTERS' HALL PHILADELPHIA.

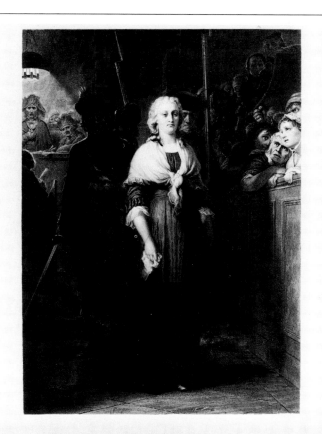

MARIE ANTOINETTE

Historical prints

Prints commemorative of national glories, especially those on the career and life of George Washington, are common to all established historical societies in New England *(fig. 19)*. The Institute owns many, as well as views of battles in which Essex County men participated—Louisburg, Quebec, Bunker Hill, and the confrontations in the War of 1812. Prints collected on the European theaters of war include a large number centered on the affairs of France—the Siege of Antwerp in the 1830s, satirical lithographs in the 1860s on "the invincible triumvirate" of Bismarck, Moltke, and von Roon, and a number, sympathetic to both Jacobin and royalist, on the French Revolution.

Marie Antoinette (fig. 20) was printed in Paris and published there in London, Berlin, and New York in 1857. The engraving by Alphonse Francois was based on the painting by Paul Delaroche, executed in 1851, over fifty years after the queen was sentenced and executed. Historical prints are often anectodal, histrionic, exaggerated, or inaccurate. Marie Antoinette is portrayed with sensitive immediacy, in pallid resignation—unadorned, defeated, introspective, and unseeing.

19. *The First Prayer in Congress,*
1848. Engraving and mezzotint by H. S. Sadd after T. H. Matteson, and printed by L. A. Elliot and Company, Boston; 41.8 x 56.8 cm. (115,816).

20. *Marie Antoinette,*
1857. Engraving by Alphonse Francois after painting by Paul Delaroche (1851) printed by Goupil and Companie, Paris; published in Paris, London, New York and Berlin; 51.7 x 38.7 cm. (121,411).

CAPT.^N JAMES MUGFORD,

OF THE

SCHR. FRANKLIN CONTINENTAL CRUISER 1776.

[Body text illegible]

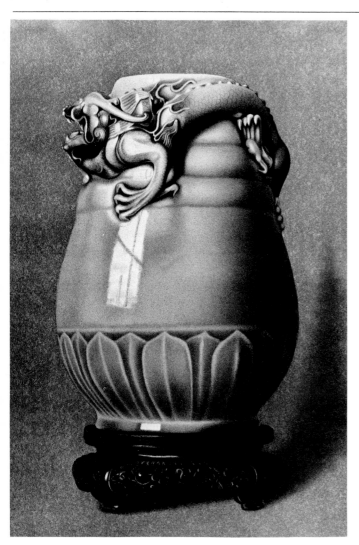

Capt. James Mugford, of the Schr. Franklin was one of the two historical commemorative prints issued by Glover Broughton, the town clerk of Marblehead, for his fellow citizens who were either participants or descendants of those who took part in two events, the massacre of American prisoners of war during the War of 1812 and the capture of a British ship by Marbleheaders during the Revolution *(fig. 21)*. Harry T. Peters, the first major historian of American lithography, said that the text below the Mugford print was "surely a very noble subtitle for a fine American lithograph; it is one of the best."[6] The text details the cumulative effect upon the subsequent independence of America of Mugford's capture of the British boat loaded with ammunition.

A category of prints which can be classed "historical" are those which came to the Institute as a result of the Salem Lyceum lectures. Resting in a storeroom where they were probably deposited not long after the lectures were delivered, this group of prints includes a broadside on the discovery of Tutankhamen's tomb and the celebrated mummy, broadsides on temperance, and a set of trial proofs from the firm of L. Prang and Company, Boston. This firm, the foremost in the field of chromolithography in the world, produced the monumental *Oriental Ceramic Art,* (New York, 1897). In addition to depicting with photographic reality the shapes and tones of oriental pottery *(fig. 22),* these proof impressions give rare indications—in the margins which would be cut from the final impressions—of the names of lithographic printers who worked for Prang, and whose skills were a necessary component of the making of the chromolithographs for which Prang was so famous.

21. *Capt.ⁿ James Mugford of the Schr. Franklin Continental Cruiser 1776,* 1854. Tinted lithograph with added watercolor, printed by L. H. Bradford and Company, Boston; 33.5 x 45.8 cm. (108,334).

22. *[Pea-Green Celadon Vase],*
Plate XL from *Oriental Ceramic Art,* by William T. Walters (New York, 1897). Chromolithograph printed by L. Prang and Company, Boston; 34 x 23 cm. (133,958.22).

Sheet music and genre illustration

The sheet music collection at the Institute is not a large one, though it has some distinguished examples of American illustration. It concentrates on Essex County imprints, Essex County scenes or events, or artists with some identifiable connection with the area. Fitz Hugh Lane (1804-1865), one of the best-known nineteenth-century American marine painters, began his professional artist's career as a lithographic draftsman in Boston. The Institute owns several music sheets illustrated by him in this period, of which five were recently acquired. *Salem Mechanics Light Infantry Quick Step* depicts a militia unit drilling on Washington Square in Salem. *The Maniac (fig. 23),* though not a Salem scene and not as well known, is nonetheless an unexcelled example of Lane's skill with the lithographic crayon. He understood well the ability of lithography to convey tonal qualities, to build up rich dark areas—characteristic of his best works.

Winslow Homer (1836-1910), also worked as an apprentice in a lithography shop in Boston. But it was after he had established himself as an artist that he drew a series of genre illustrations on the Civil War, entitled *Campaign Sketches (fig. 24),* lithographed by L. Prang and company of Boston, in 1863. The Institute owns the complete set, as well as several music sheet title-pages and book illustrations drawn on stone by Homer.

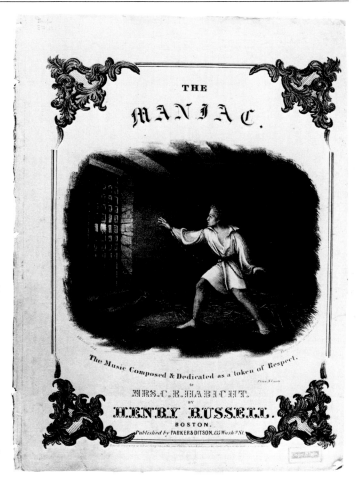

23. *The Maniac,*
by Henry Russell, 1840. Lithograph music sheet title-page illustration by Fitz Hugh Lane, printed by Thayer's Lithograhic Press, Boston; 33.3 x 25.5 cm. (134,192).

24. *Foraging,*
one of the six illustrations by Winslow Homer for *Campaign Sketches,* 1863. Tinted lithograph printed by L. Prang and Company, Boston; 26.9 x 21.7 cm. (134,006.1).

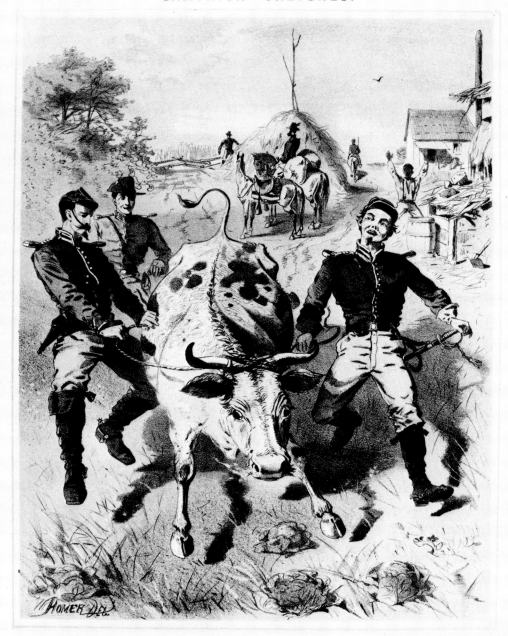

FORAGING.

The earliest houses in the New England colonies in the seventeenth and early eighteenth centuries had few prints on their walls. Though less costly than oil paintings and therefore more attainable, prints were still not common. Almost none at the time were printed in this country. Yet as wealth increased, people began to acquire interesting prints either from a simple desire to fill blank walls or from more complex desires to enrich their daily lives. Beginning in the second quarter of the eighteenth century, printmaking in America became established.

Sea captains, clergymen, and successful merchants in Essex County all owned prints by the end of the eighteenth century. Some of the items from the library of Andrew Oliver, a Salem writer and book collector, included "Hogarth's Originals & a book of plates," valued at $20;[7] the Reverend John Prince, pastor of the First Church in Salem from 1779 to 1836, owned an impression of *Christ riding in Triumph into Jerusalem.* M. O. Pickering owned *Piano Elevato dell'inclita citta di Venezia,* and Captain John Crowninshield, the first owner of the Crowninshield-Bentley House, possessed at the time of his death "In the Western Lower Room/ 8 framed picktures carved, 4 small Ditto,/ 12 Ditto Black framed./ In the Western Chamber/ 7 Picktures/ In Kitchen, 9 Picktures,/ In the Garret/ A Prospect Glass."[8]

The pictures were probably prints, since in eighteenth-century inventories, paintings were usually carefully noted. One can surmise that some of the prints were probably in sets, and the unmodified "picktures" relegated to the kitchen and the bedroom were probably unframed. And, in the attic to be brought out on special occasions, was the "prospect glass," the eighteenth-century equivalent of a "View Master," used to look at large engraved and colored European views.

The lack of specificity in this inventory is typical and lamentable. But *types* of prints in such inventories are known through contemporary journals, advertisements, and surviving examples. They were predominantly views and portraits. Interest in European fine arts prints increased markedly toward the end of the eighteenth century. In educated households, there were soon seen prints after Hogarth, Poussin, and other esteemed artists

(fig. 25). The trend became so pronounced as to cause an English journal to publish a warning to prospective buyers against "collecting all works of any master . . . superstitious veneration for names . . . to rate their value by their scarceness . . . buying copies for originals . . . purchasing bad impressions." Among the caveats were purchasing poor Rembrandts or atypical Wouvermans:

I have known a collector of Rembrandt ready to give any price for two or three prints which he wanted to complete his collection; though it had been to Rembrandt's credit, if those prints had been suppressed. . . . Rembrandt has long been the fashionable master. Little distinction is made: If the prints are Rembrandt's, they must be good. In two or three years, more perhaps, the date of Rembrandt will be over: You may buy his works at easy rates; and the public will have acquired some other favourite . . . [A late celebrated collector of pictures showing his novelties], 'now, Sir, said he, I will shew you a real curiosity: There is a Woverman without a horse in it.'—The circumstance, it is true, was uncommon; but it was unluckily that very circumstance, which made the picture of little value.[9]

Six months after this article appeared, the *Universal Magazine* published a sequel establishing how one arrived at "Picturesque Beauty." These books and periodicals were in Salem soon after publication; whether these articles influenced Salem buyers or not, the Institute collection has no Rembrandt, but does have several prints with acceptable picturesque beauty after Poussin and Wouvermans.

25. *Les Chasseurs Sortant de la Forest,* ca. 1750. Engraving by I. Wachsmuth after painting by P. Wouvermans, printed chez Moyreau, Paris; 20.3 x 29.3 cm. (133,755.22).

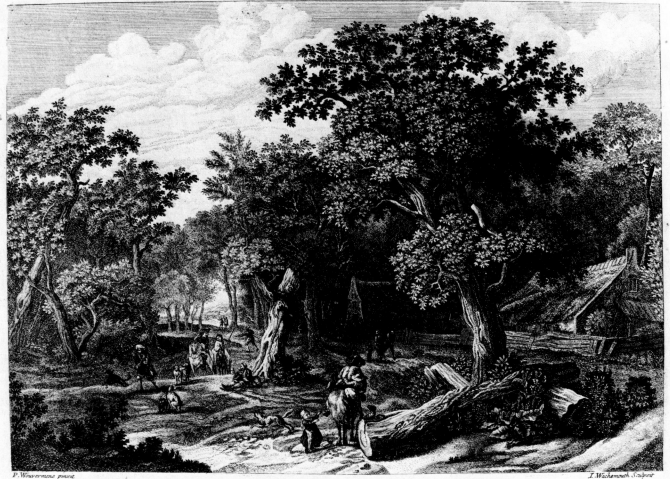

P. Wouvermens pinxit.

I. Wachsmuth Sculpsit.

LES CHASSEURS SORTANT DE LA FOREST.

Gravé d'après le Tableau Original de P. Wouvermens de 3. p. 3. pou.
de haut sur 2. p. 9. p. 6. lig. de large, qui est au Cabinet de M.R ORRY DE FULVY.

CONSEILLER D'ETAT INTENDANT DES FINANCES

A Paris chés Moyreau Avec Privilege du Roy.

et a Augspourg chez Negoce de l'Academie Imperiale Francensienne.

avec Privilege de Sa Majeste Imperiale.

2.

Of the portraits owned by Salem residents, many were by Peter Pelham (1697-1751), mezzotint engraver. During his early career in England, he had produced from paintings engraved portraits of George I, George II, Cromwell, and James Gibbs, architect, among other prominent Britons. So it was as an accomplished printmaker that Pelham arrived in Boston, where he soon made a mezzotint portrait of an eminent divine, *Cottonus Matherus,* in 1728. Pelham became colonial Boston's most important portrait printmaker, and produced, in all, prints of twelve New England clergymen and two leaders of His Majesty's forces in the colonies, *His Excellency William Shirley* and *Sir William Pepperrell.*[10]

The portrait of *The Reverend Charles Brockwell. A:M.,* rector of Christ's Church in Boston, was executed in 1750 *(fig. 26).* In poor condition, it nonetheless has an interesting catalog of names on its reverse side, written by two different persons. If the names are those of former owners, Brockwell himself was first owner of the print. At any rate, some former possessor added below the main title, in pen and ink script meant to approximate the lettering engraved onto the plate, the words "and Rector of St. Peters Church from 1738 to 1746 in Salem."

Both frames and glass were expensive in the eighteenth century, as they are now, and were a luxury for which the colonist found an easy substitution; prints to be hung on walls were often backed with linen, the edges were then bound with a sewn border cloth strip. At the top, one or two loops of the cloth were added for hanging. Prints so displayed were subject to the household vagaries of dust, smoke, fly specks, grime, children's dirty fingers, damp walls, and, if hung close to windows, the damaging rays of the sun.

His Most Sacred Majesty GEORGE III King of Great-Britain, France, and Ireland; Defender of the Faith, et cetera, is a woodcut made in England around 1765 *(fig. 27).* Owned by some colonist, it was bound in the manner just described. In addition to suffering all the maladies from household routines, this print has two distinct cracked lines, indicating that it lay folded for many years. This is no surprise, as within one generation of its printing, rebellious colonists would put away this print for portraits of another George.

The medium of woodcut used for the portrait of *George II* and the companion print of *Her most excellent majesty Queen Charlotte* was uncommon at this period. Both these prints were fairly crudely executed and are larger than most woodcuts. They were hand-colored, though more simply than for most important prints of the period. Perhaps this pair was intended for the "meaner sort," or less wealthy colonists.

The prints were based on *George the Third King of Great-Britain, &c. &c. &c.* "publish'd according to Act of Parliament, by Assignment from Mr. Meyer; & Sold by J. Boydell Engraver in Cheapside; & J. Jefferys, at Charing Cross. 1761. J. Meyer Pinxt. Jo. McArdell fect.," and McArdell's mezzotint companion portrait of Queen Charlotte. The measurements of the two woodcuts correspond almost exactly to those of the mezzotints.

Prints portraying elegant subject matter became popular in America, as colonists sought examples of the social customs and dress of the English upper classes. Engraved portraits appeared which were based on paintings by Godfrey Kneller, Sir Joshua Reynolds, and Sir Thomas Lawrence. More than a few well-to-do homes had stipple engravings by Bartolozzi after the charming paintings by Angelica Kaufmann, such as the set depicting the judgment of Paris and Aurora which hangs in a bedroom of the Pingree House. Also popular were sets of prints entitled "Emblems," or allegories, of England and Scotland, Ireland and Wales; of America, Asia, Africa, and Europe; and of Peace and Plenty.

26. *The Reverend Charles Brockwell, A: M.*,
1750. Mezzotint by Peter Pelham, Boston; 29.5 x 24 cm. (115,631).

27. *His Moſt Sacred Majesty GEORGE III, King of Great-Britain. . . ,*
ca. 1765. Woodcut with added watercolor, printed in London;
46 x 36.7 cm. (115,553).

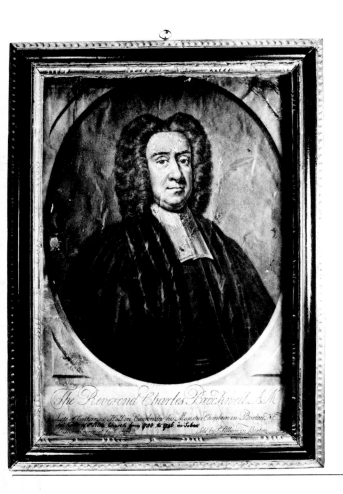

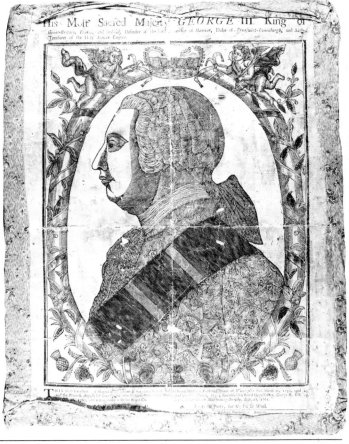

The subjects were an evocation of the classical past, a spirit which the English also echoed in their architecture, decorative arts, and dress. But allegorical scenes were not the only ones to which the style was applied in prints. It is also glimpsed in the upper-class genre prints of the period, such as the Institute's series including *The Favorite Rabbit, The Dog's First Sight of Himself, Betsy in Trouble,* and *Tom and His Pidgeons (fig. 28).* These were done in stipple, a self-proclaimed invention of three French engravers around 1745, but so fervently adopted by the English that it became known at the end of the eighteenth century as the "manière anglaise." The English contribution to the technique was the development of printing in color, soon used almost constantly for prints of especial appeal. In the Institute's vast and important China collection is a color stipple engraving of *Tchien-Lung, Emperor of China,* engraved by John Chapman and published in London in 1801; and displayed in the east parlor of The Peirce-Nichols House are two color stipple engravings, *A Girl Going to Market* and *A Boy Returning from Fishing,* once owned by Jerathmael Peirce himself.

At the time that these prints were issued to appeal to the print-buying public, weightier questions of political and economic theories were also major concerns of citizenry of America and Europe. Thomas Paine, Hume, Burke, William Pitt, Adam Smith, Rousseau, and the Federalists (a number of whose printed portraits are in the Institute's collections) discussed in writing social-contract and philosophical and parliamentary questions. Abstractions coupled with the vogue for the neoclassical mode led to the same treatment in the graphic arts. Classical authors were often read with current issues and events in mind, and earlier artists' work reinterpreted to fit the times.

Modern Europe in the preceding two centuries had arisen from a consolidation of principalities into countries and nations, and the growth of an increasingly mercantile middle class resulted. Trade became the means whereby foreign markets added to the "Wealth of Nations." In such a frame of mind, a print which conveyed both attitudes is singularly appropriate, as it must have seemed at the time. Whether or not this print was widely circulated at the end of the eighteenth century—as it probably was, since prints after the marine paintings of Joseph Vernet (1712-1789) were very popular—it evokes for current connoisseurs the force that drove Salem's sea captains and merchants to the Orient. *Currit mercator ad Indos Per mare pauperium fugiens, per saxa per ignes:* "The merchant-trader races to the Indies, fleeing poverty through fire, through seas, through rocky ground." The motto closely approximates that which Salem finally adopted in 1839: *Divitis Indiae, usque ad ultimun sinum,* "seeking the wealth of the Indies, even to the farthermost bay" *(fig. 29).*

Straightforward views were one of the commonest subjects sold to the colonists. Views were often of their native country scenes, of biblical significance, or of cities visited, like *Quebec, The Capital of New-France,* by Thomas Johnston, hanging in the Crowninshield-Bentley House. The perspective plans of battles and the elevations of prominent squares and public buildings in European cities—all contributed to the colonists' quickened remembrances of architecture, dress, and customs of the countries left behind.

Publishers such as the Caringtons and the Bowles in their varying partnerships, and Robert Sayer, produced countless sets of views of London, Paris, and even cities in America with less accuracy than pictorial charm. Six of Sayer's engraved and colored views of London hang above the fireplace in the west parlor of the Crowninshield-Bentley House.

28. *Tom and His Pidgeons,*
ca. 1800. Color stipple engraving by Charles Knight after J. Russell, London; 27.1 x 35.7 cm. (108,281).

29. *Currit mercator ad Ind[i]os Per mare pauperium fugiens, per saxa per ignes,* "The merchant-trader races to the Indies, fleeing poverty through fire, through seas, through rocky ground," ca. 1810. Engraving by F. Pedro after N. Cavallis, from a painting by Joseph Vernet, printed in Italy; 30 x 40.5 cm. (133,755.42).

TOM AND HIS PIDGEONS

Currit mercator ad Indos

Per mare pauperiem fugiens, per saxa per ignes

In addition to views, these firms produced series of narrative works, some of the most noteworthy being prints after Hogarth, such as *Farmer's Return from London,* in the Crowninshield-Bentley House, and scenes from the mid-eighteenth-century novel, *Pamela,* by Samuel Richardson (London, 1740). It was printed in twelve episodes. The Institute owns at least two editions, 1745 and 1774; the latter hangs in the Crowninshield-Bentley House.

A dramatic setting sometimes encroached upon a very typical English topographical scene, such as *Temporary Retirement./ or the Squires last visit to Sally,* one of a series entitled, "A Collection of Beautiful Landskips, with a Variety of Comic figures" *(fig. 30).* Typical of many prints of the period, a few selected colors were applied according to a scheme determined for their mass production; the washes were therefore applied with a casual quickness.

As American prints became more plentiful and more native heroes were embodied in mezzotint and stipple, one figure—George Washington—was portrayed more often than any other. The collection at the Institute, like that of similar historical collections in the United States, contains many images of the "Father of our Country" —at home with his family, at Dorchester Heights, in studio pose (after paintings by Gilbert Stuart, Rembrandt Peale, and others), at Mount Vernon, in New York for his inaugural, at his death, and at his symbolic *Apotheosis,* as depicted by the Philadelphia artist, John J. Barralet *(fig. 31).*

Engravings published in the major centers of Philadelphia, Boston, and New York made their way to more provincial towns where local printmakers often copied them. The portfolio of many a schoolgirl of the early nineteenth century contained a likeness of some Washington print. A local Salem artist, Joseph Hiller, Jr. (1777-1795), engraved a print after one made in New York by Joseph Wright. Hiller's version of John Hancock hangs in the Peirce-Nichols House.

A number of Essex County residents achieved national prominence after the Revolution in the newly formed American federal government. Timothy Pickering (1745-1829) was soldier, statesman, administrator, politician, and "an outstanding member of the die-hard school of Federalism,"[11] a popular stance in Salem. When Pickering became secretary of state, he was a natural subject for the New York and Philadelphia engraver, Charles Balthazar Julien Fevret de St. Mémim *(fig. 32).* Pickering's portrait, done around 1796, is one of several St. Memim portrait engravings owned by the Institute. Though Pickering's Federalist politics were favored by the majority of Salem residents, his personality and actions were criticized by many. Salem's diarist, the Reverend William Bentley, took issue with Pickering's politics, however, calling him "a curse to the nation."[12]

The prints discussed in this section are representative, indeed some are the actual ones which were to be found in Salem in the eighteenth and early nineteenth centuries, the period so well exemplified by the Essex Institute's six historic houses.

30. *Temporary Retirement./ or the Squire's private Vifit to Sally,* 1781, from *A Collection of Beautiful Landskips, with a variety of Comic Figures.* Engraving with added watercolor published by Carington Bowles, London; 14.3 x 18.9 cm. (100,657).

31. *Apotheosis. Sacred to the Memory of Washington./ OB 14 Dec. AD 1799/ AEt 68,* 1800. Stipple engraving by J. J. Barralet, Philadelphia; 60.5 x 46.5 cm. (106,774).

32. *[Timothy Pickering],* ca. 1796. Engraving by C. B. J. F. de St. Mémin, Philadelphia; circle, 5.5 cm. diam. (116,272).

The earliest printed views of Salem itself were made, not by Salem, but by Boston printmakers. Samuel Hill engraved the Salem Court House as one of his many scenes of local towns for the March 1790 issue of *Massachusetts Magazine,* published in Boston. Six years later, when the Salem Marine Society, which had been founded in 1766, decided to issue its members a certificate, Hill was chosen to execute the plate. The resulting work is the first printed view of Salem harbor. (The earliest Essex County town view appears to be that of Newburyport, published the year before. The print was the work of Benjamin Johnston, a son of Thomas Johnston, an earlier Boston engraver and man of many trades.[13])

The large view at the top of the *Salem Marine Society* certificate shows both Union and Derby wharves and the newly built lighthouse *(fig. 33).* The smaller scenes depict the scenes of supporting activities for Salem's livelihood in the maritime trade—a vessel launching, a ship careened for breaming, a screw press for fish, and a schooner offshore. The certificate was used again and again well into the nineteenth century, as are attested to by the dates on copies at the Institute. The plate is now on deposit at the Peabody Museum of Salem.[14]

The third known earliest view, the *Salem Iron Factory (see fig. 4),* was also done around 1800 by a Boston engraver—this time, George Graham. The stock certificate was later copied by another more primitive hand for the *New Hampshire Iron Factory.*

A membership certificate for the other major organization in Salem, the *Salem Charitable Mechanic Association,* founded in 1817, was probably made when the society was incorporated in 1822 *(fig. 34).* The image, drawn by John Ritto Penniman, is steeped in symbolism, as was the society itself. The background view of Salem harbor was based on Hill's view for the Marine Society certificate, and in part on an earlier certificate which Hill had engraved for the Massachusetts Mechanic Association around 1800. In place of Hill's depiction of a scale which in a spirit of idealism balanced goods with services and artisans' tools, Penniman spread tools and other evidences of industry around the foreground of his print. Archimedes, the patron saint of the society,

33. *Salem Marine Society,* membership certificate, 1797. Engraving by Samuel Hill, Boston, after a drawing by Abijah Northey, Salem; 21.7 x 27.7 cm. (BR/ 360.1/ S17.15).

34. *Salem Charitable Mechanic Association,* membership certificate, ca. 1822. Engraving after a drawing by John R. Penniman and printed by Annin and Smith, Boston; 27 x 36 cm. (BR/ 360.1/ S16/ 1817).

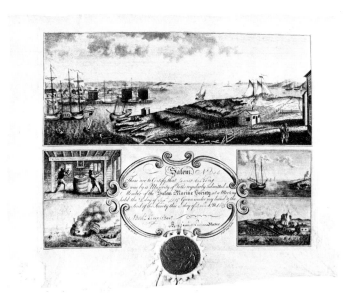

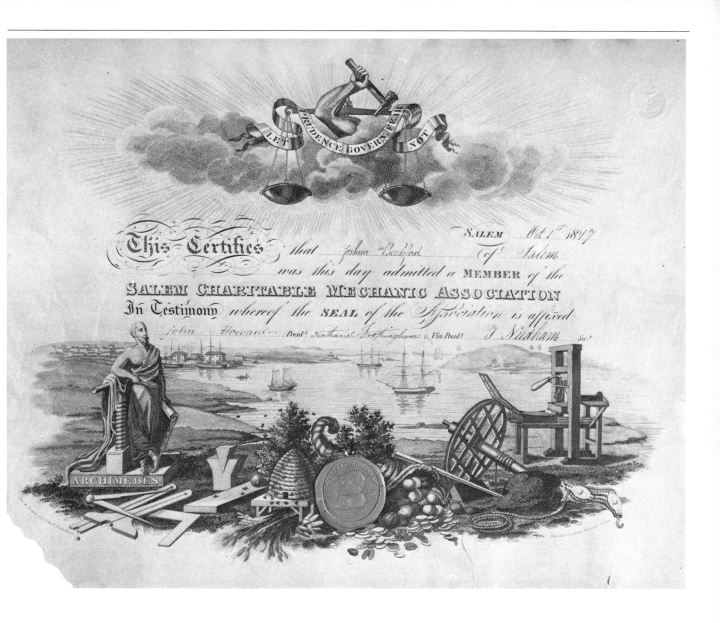

This Certifies that Joshua W. Beckford of Salem

SALEM Oct 1st 1847

was this day admitted a MEMBER of the

SALEM CHARITABLE MECHANIC ASSOCIATION

In Testimony whereof the SEAL of the Association is affixed

John Howard Prest! Nathaniel Frothingham Vice Prest! I. Needham Sec.

LET PRUDENCE GOVERS. FEAR NOT

ARCHIMEDES

was moved from a wax seal to a prominent spot at the left front, and rested on a large vice screw instead of against the more traditional ruins of a column. In addition to the ever-present image of a beehive, Penniman drew sheaves of wheat, and from his cornucopia spewed forth, in addition to the usual produce, an abundance of coins. At the right Penniman depicted a printing press. The inclusion of these last two images was not only characteristically symbolic of the society but significant for Penniman as well, for his overzealous printing of counterfeit money landed him in jail about seven years later.

If these early prints which incorporated views of Salem were done in Boston, the inference is that Salem did not have a capable printmaker or a press. Salem did have at least one printmaker as early as the last quarter of the eighteenth century. Samuel Blyth (1744?-1795), was known primarily as a painter of coats of arms, window frames, checkerboards, closet doors, chimneys, genteel and fall-back chaises, guns and gun carriages, the governor's pew in St. Peter's church. He made picture frames and spinets; he gilded apothecary bottles, looking glasses, eagles, and cupola balls; and in addition, Samuel Blyth made mezzotints. Only one, Cleopatra, is signed, but serves as the basis of the attribution of four others: portraits of Revolutionary generals Charles Lee, Israel Putnam, and Joseph Warren, and the capture of Major André (fig. 35).[15]

The mezzotinting in these prints was done in basically one tone, a rather primitive approach to a medium capable of infinite gradations. The benign expressions and almost identical poses of three out of four of the protagonists belie the inherent violence of the incident. Although the sources for the portraits are known (they were probably based on mezzotints by an anonymous engraver published by C. Shepherd in London in 1775), that of the André is not at this time. But the print is the earliest-known treatment of the subject. Blyth may have based his depiction on a similar scene for an earlier confrontation and simply changed the title, a not uncommon practice of printmakers.

North of Salem, Newburyport was the setting of some novel printmaking a few years later. James Akin (ca.

1773-1846) was busily engraving caricatures of local citizens. Originally from Philadelphia, he is reported to have come to the Salem area with Timothy Pickering when he was relieved of his post in President Adams's cabinet.[16] A more probable explanation is that Akin came north to work for Jacob Perkins, an engraver and inventor who had sought a testament to his invention of stereotype from Akin about three years earlier.[17] Akin engraved a certificate, after a drawing by his wife, for the Newburyport Female Charitable Asylum in 1802. He also engraved a frontispiece after a drawing by Michel Felice Corné for the second edition (Salem, 1804) of *The Power of Solitude* by the youthful Joseph Story of Salem before Story became a nationally respected jurist. With publication of the *Perpetual Almanack,* Akin introduced the Philadelphia practice of printing with colored inks to Essex County, if not to Boston also.

One of his most famous caricatures is of Timothy Dexter, Newburyport merchant, seen bedraggled, with peculiar gait and hairless dog (fig. 36). Among the various captions is a quote from *Hamlet:* "O what a work is man! How noble in faculties, how infinite in reason!" By whatever quirk of personality Dexter was driven, it was not stupidity; his house, ornamented atop its fence posts with several dozen life-size statues whose attributions Dexter changed at whim, attracted many of the curious across the Essex chain toll bridge of which he owned the controlling number of shares.

Akin is reported to have done some engraving for *American Coast Pilot* by Edmund March Blunt, published eventually in twenty-one editions. Relations deteriorated between engraver and publisher to the point that, upon their meeting in a downtown hardware store, they traded insults and then blows. Blunt threw a skillet which missed Akin, went through the window, and hit Captain Nicholas Brown, the nephew of Moses Brown, skipper of the *Merrimac.* The incident provoked a broadside, "The Skillet/A Song/Written in the Iron Age to the tune of Yankee Doodle," and a separate engraving by Akin which depicted Blunt, though not identified, in the act of throwing the skillet. This engraving, entitled *Infuriated Despondency,* plus another of the *Merrimac* and the coat of arms of the Browns were transferred to some

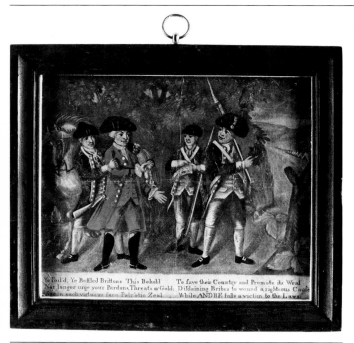

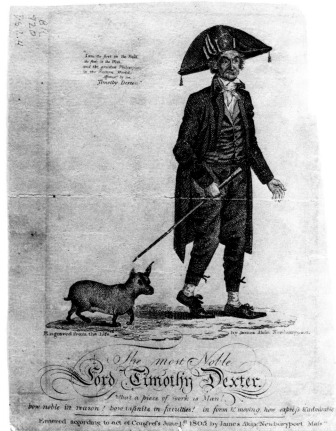

35. [*The capture of Major André*],
ca. 1780. Mezzotint with added watercolor attributed to Samuel Blyth, Jr., Salem; 17 x 23.7 cm. (103,215f).

36. *The most Noble Lord Timothy Dexter,*
1804. Engraving by James Akin, Newburyport; 18.3 x 15.1 cm. (with text). (BR/ 920/ D52.4).

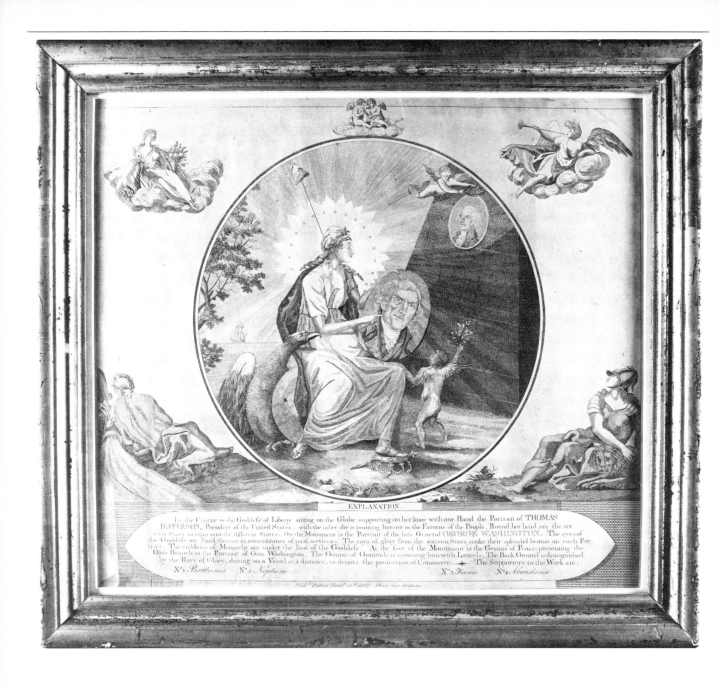

EXPLANATION.

In the Center is the Goddess of Liberty, sitting on the Globe supporting on her knee with one Hand, the Portrait of THOMAS
JEFFERSON, President of the United States, with the other she is pointing him out as the Favorite of the People. Round her head are the six-
teen Stars to represent the different States. On the Monument is the Portrait of the late General GEORGE WASHINGTON. The eyes of
the Goddess are fixed thereon in remembrance of past services. The rays of glory from the sixteen Stars strike their splendid beams on each Por-
trait. The emblems of Monarchy are under the foot of the Goddess. At the foot of the Monument is the Genius of Peace presenting the
Olive Branch to the Portrait of Gen. Washington. The Genius of Gratitude is crowning him with Laurels. The Back Ground is distinguished
by the Rays of Glory, shining on a Vessel at a distance, to denote the protection of Commerce. The Supporters to the Work are:
Nº 1. Britannia Nº 2 Neptune Nº 3 Fame Nº 4 Abundance

Pub.ᵈ Salem Janʳ 1ˢᵗ 1807 Price two Dollars

37. *In the Center is the Goddefs of Liberty supporting . . . the Portrait of Thomas Jefferson . . .*, 1807. Engraving attributed to Henry Dean, Salem; 38.5 x 44 cm. (121,609).

38. *Thomas Jefferson*, 1801. Engraving by Auguste Desnoyers after Boucher, Paris; 25.2 x 19.8 cm. (130,083).

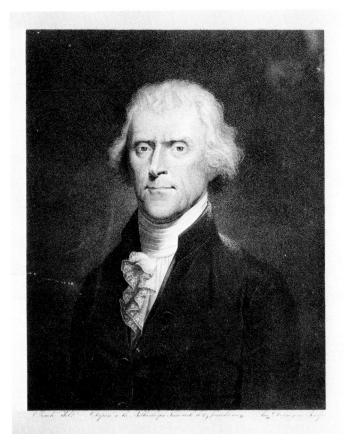

THOMAS JEFFERSON.

Prisident des Etats unis de l'Amerique a un tier

of Brown's china made in England. *Infuriated Despondency* also appeared on "vessels of less esteem." Blunt understandably tried to buy up all the china and brought suit against Akin, which caused the artist sufficient worry that he returned to Philadelphia in 1807, and Essex County thereby lost its earliest graphic satirist.

Within a year or so, another publisher, Henry Dean of Salem, brought out his *Analytical Guide, to the Art of Penmanship Containing A Variety of Plates Collected and Arranged By Henry Dean W. M. and Correctly Engrav'd by Thomas Wightman*, published in Salem by Joshua Cushing. Wightman was a Boston engraver; if there had been a suitable engraver or copperplate press in Salem, the job probably would have been done locally. So Henry Dean, "Writing Master," decided to take up engraving.

Akin had advertised in April 1804 that he had for sale some writing book covers—*Sailors Glee, Turkeys,* and *Infuriated Despondency.* Henry Dean of Salem printed some also—including one identical subject, the turkey. He also "Printed & Sold" a lion and lioness, a goddess with an anchor, Justice with sword and scales, and a print entitled *Covetousness,* probably presumed of eminent suitability for the students of his bookkeeping course.

Dean was probably responsible for the first separately published large engraving printed in Salem—an homage to Thomas Jefferson, "Pub.ᵈ Salem Jan.ʸ 15 1807 Price two dollars" *(fig. 37).* The print was published at a time when speculation was mounting on whether or not Jefferson would seek a third term as president. The *Salem Gazette*, a Federalist paper, and the rival *Essex Register* traded sallies. The Reverend William Bentley, responsible for some of the editorial positions of the *Register,* was brought into the controversy. The print, although untitled, has a lengthy *Explanation* understandable from a teacher of penmanship:

In the Center is the Goddefs of Liberty sitting on the Globe supporting on her knee with one Hand the Portrait of Thomas/ Jefferson, President of the United States. with the other she is pointing him out as the Favorite of the People. Round her head are the six-/ teen Stars to represent the different States: On the Monument is the Portrait of the late General George Washington. The eyes of/ the glory from the sixteen Stars strike

their splendid beams on each Por-/ trait. The emblems of
Monarchy are under the feet of the Goddefs. At the foot of the
Monument is the Genius of Peace, presenting the/ Olive Branch
to the Portrait of Gen. Washington. The Genius of Gratitude is
crowning him with Laurels. The Back Ground is distinguished/
by the Rays of Glory, shining on a Vessel at a distance, to denote
the protection of Commerce. The Supporters to the Work are:/
Nº 1 Britannia/ Nº 2 Neptune/ Nº 3 Fame/ Nº 4 Abundance.

Dean's sources for the pictorial part of the engraving
were well-known engravings after Gilbert Stuart's
portrait of Washington and decorative elements he had
seen in such English publications as *European Magazine.*
The brickwork was used by both English and New York
printmakers. The portrait of Jefferson was taken, not
from an American print, but from the very engaging
portrait engraved by Auguste Desnoyers in France in
1801, a copy of which is known to have belonged to the
Reverend William Bentley *(fig. 38)*. The minister may
have allowed the use of his print, though he does not say
so in his diary. Dean, however, is mentioned on
numerous occasions, with increasing disapprobation. He
is not known to have published any more engravings on
his own, and the eighteenth edition of his *Hocus-Pocus, or
the whole art of Legerdemain*, with wood engravings by
Abel Bowen, was published in 1817 in Boston, to which
Dean had repaired.

During Akin's time in Newburyport, there were other
engravers there as well: William Hooker and David
Fairman, and William J[?] Gilman. Hooker and
Fairman printed *The Marine Society of Newburyport*
certificate, based on an English model, plates for *Dean's
Academical Companion* (1806), and an advertisement for
the famous Wolfe Tavern. By 1812 Fairman was in
Philadelphia, and Hooker had followed Blunt to New
York City. The Gilmans printed mostly wood engravings
for book illustrations, an unusual proportion of which
were for children's books and were drawn with humor
and delicacy. According to Sinclair Hamilton, they
"should perhaps be ranked among our earliest engravers
[on wood]."[18]

During the War of 1812, many sailors from Salem and
neighboring Marblehead were captured by British ships
and subsequently sent to Dartmoor prison in England,

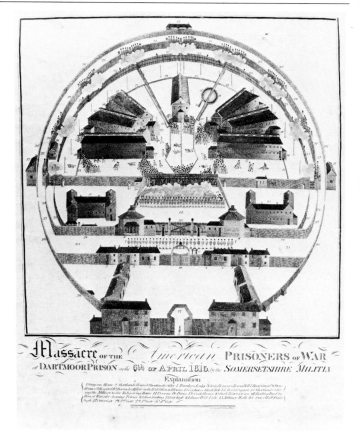

39. *Massacre of the American Prisoners of War at Dartmoor Prison on the 6th
of April 1815. by the Somersetshire Militia*, 1815. Engraving with added
watercolor by George G. Smith, Salem; 37.5 x 33 cm. (115,564.4).

40. *Napoleon in Exile,*
ca. 1830. Lithograph by J. Webb, Salem, printed by Senefelder
Lithographic Company, Boston; 35.5 x 28.5 cm. (107,907).

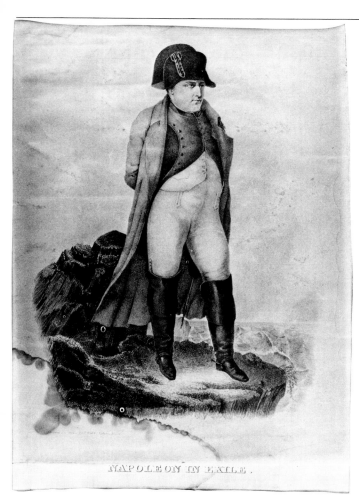

NAPOLEON IN EXILE.

about fifteen miles from Plymouth. The area, a bleak and barren moor, was "devil's land" to the local inhabitants. An American survivor of the prison recorded, "This high land receives the sea mists and fogs, and they settle on our skins with a deadly dampness. . . . This moor affords nothing for subsistence or pleasure. Rabbits cannot live on it. Birds fly from it. . . ."[19]

News of the war's end had already been received by the prisoners, and they were awaiting transportation home when a spirited game of handball in the prison yard was transformed into the untimely and unfortunate shooting of a number of the prisoners. An untitled view of the massacre scene was printed for a frontispiece account of *Journal of a Young Man of Massachusetts* (Boston, 1816). The same print, though with variations, was published in Salem with a very explicit title, *Massacre of the American Prisoners of War at Dartmoor Prison on the 6th of April 1815. by the Somersetshire Militia (fig. 39).* The engraver's imprint reads, "George G. Smith, Salem, Mass. Sc." He evidently printed the plate in Salem, though before long he too would be in Boston, where he had a very long and eminent career as an engraver.

This early flurry of printmaking activity in Newburyport and Salem was important and novel, though short-lived. And printmaking, whether on copper or wood, soon became concentrated in Boston. Lithography shops opened there in 1825 and 1827. Salem had no shop until after the Civil War, and then only for a year or so, if that. The same seems to be true for Newburyport, Danvers, and the Andovers. Print publishers and artists who wished to practice what soon became the nineteenth century's preeminent technique had to go to Boston.

Napoleon in Exile was drawn by "J. Webb, Salem, Mass.", probably a mariner, and was printed in Boston by the Senefelder Lithographic Company between 1827 and 1833 *(fig. 40).* The Salem connection was important to note, but place of origin was rarely indicated by lithographic artists.

Salem men were on the ship which transported Napoleon to exile on St. Helena, an island off the coast of Africa. A description of this voyage, *Buonaparte's*

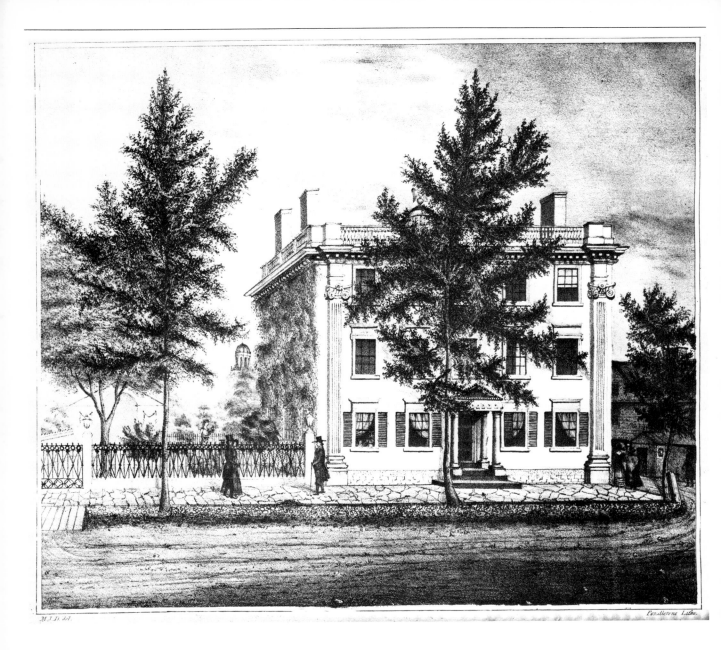

41. [*Pickman-Derby-Brookhouse House, Salem*],
ca. 1830. Lithograph by Mary Jane Derby and printed by Pendleton, Boston; 26.2 x 32 cm. (104,424.5).

42. [*Barton Square Church "Independent"*],
ca. 1830. Lithograph attributed to J. F. Colman and printed by Senefelder Lithographic Company, Boston; 20.5 x 23 cm. (131,409).

Voyage to St. Helena; Comprising the diary of Rear Admiral Sir George Cockburn, . . . 1815, was published in Boston in 1833. The manuscript from which the book was printed was one of only two copies of the diary (the other was under cover in England), given to the publisher by Captain J. F. Brookhouse "lately a resident of St. Helena, but now at Salem."[20]

This association, as well as demonstrating admiration for the Little Emperor's military skills and streak of independence, made him an object of fascination to Salem residents. They collected items of his clothing, kitchen equipment, pieces of his shroud when his body was removed from St. Helena in 1840, a personal handkerchief, and other mementos. The Institute's collections contain these items, along with a large number of prints, both American and European, on Napoleon—his military exploits, state ceremonies, residences at St. Helena, and portraits.

Mary Jane Derby, educated in typical fashion for a young lady in the first half of the nineteenth century, studied music, penmanship, and drawing. She, like a number of young women of her station, tried her hand at the lithographic stone. The three subjects known to have been done by her include the Pickman-Derby-Brookhouse House, her childhood home *(fig. 41);* a country house belonging to a cousin, R. C. Derby; and a view of the New Bedford Unitarian Church, of which her husband, Ephraim Peabody, was pastor.

J. F. C. may also have been a woman, one of the unidentified daughters of Henry Colman, Unitarian minister in Salem at the Barton Square Church from its founding in 1825 until he resigned in 1833. Between this job and an earlier one as a pastor of the New North Meeting House (Unitarian) in Hingham, Colman had run an academy in Brookline at which his own daughters undoubtedly learned to draw. The Colman household, according to the 1830 census of Salem, had five adolescents, but neither the birth nor baptism of any has been found. One daughter, Anna Storer, is known, because of her marriage to the well-known Salem merchant, Pickering Dodge (whose portrait is owned by the Institute). The Colman family soon moved to Deerfield, and then Colman himself (with or without his family) moved to England.

Some late-nineteenth-century hand inscribed the print of the Barton Square "Independent" Church in Salem as the work of "J. F. Colman," with no reason for the attribution *(fig. 42)*. Other prints by the same artist are *Pickman House,* now the site of the Peabody Museum's Japanese garden, and *Woodside,* reported to have been an estate in Lynn, Massachusetts, owned by a member of the Dodge family. In the foreground of the second print, two children and a man stand beside a seated woman, sketching. She may indeed have been the mysterious J. F. C.

Another Salem native who tried lithography was Sylvester Phelps Hodgdon (1830-1906). One of his earliest lithographs was the interior and exterior views of the *Tabernacle, Salem, Mass./1777-1854,* to commemorate the building deemed old and worn, and in need of replacement *(fig. 43)*. Like many nineteenth-century artists, he used lithography to help develop his skills in graphic art. Hodgdon, though always known until his death as a Salem artist, was soon sketching in Stowe, Vermont and the White Mountains. His Essex County scenes, like those of later painters, were primarily of Gloucester and Cape Ann. Regrettably, he did no prints in his later years.

In the middle of the nineteenth century, a local architect, William Emmerton, designed an amusement entitled *The Feast of Reason (fig. 44)*. A forerunner of the puzzle, and companion to the rebus, the game was to match the puns with their appropriate answers. Two versions were drawn; both were lithographed and printed in Boston, the first by T. R. Holland in 1864, the second by John H. Bufford the next year. Emmerton drew both on stone. An amateur to the printer's world, he may not have intended to have his initials print in reverse on the first version. Emmerton evidently copyrighted the first himself, but the second version was copyrighted by a Salem bookseller, C. M. Whipple. Perhaps he was inspired to try drawing on the lithographic stone after he had seen one of his drawings turned into a print.

About fifteen years earlier, Emmerton had provided the original drawing for a certificate of award for the Salem Charitable Mechanic Association's Fair of 1849 (see *fig. 14*). He probably provided the lithographic firm of Tappan and Bradford with vignette illustrations of Salem's industry, maritime interests, Pickering Wharf, the Court House, and a steam-powered engine. The lithographic artist, A. Sonrel, then probably arranged them into a composition interconnected with his own decorative border.[21]

43. *Tabernacle, Salem, Mass./ 1777-1854,*
ca. 1854. Lithograph by Sylvester P. Hodgdon, probably printed by Tappan and Bradford, Boston; 24 x 45.5 cm. (129,182.1).

44. *The Feast of Reason/ A Christmas Dinner Puzzle,*
1864. Lithograph by William H. Emmerton printed by T. R. Holland, Boston; 39.3 x 52 cm. (131,355).

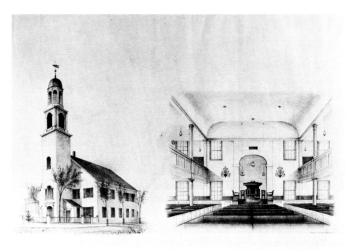

TABERNACLE, SALEM, MASS.

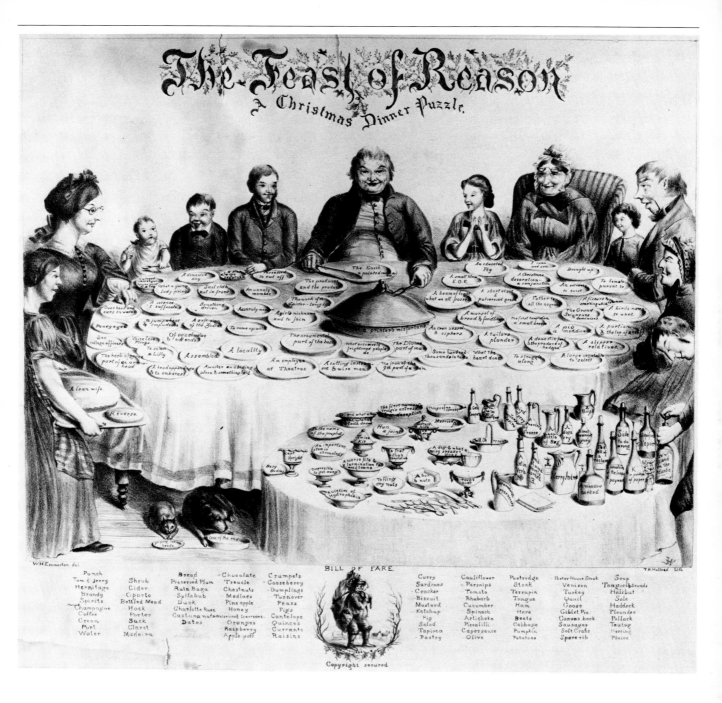

45. *Lithographic View of Washington Street, Salem, Mass.,*
ca. 1867. Lithograph by J. Warren Thyng printed by Thyng and
Babbidge, Salem; 39.7 x 50.6 cm. (115,722.2).

46. *1,001 Nights Festival,*
1897. Color lithograph by George Elmer Browne printed by Forbes
Lithographic Company, Boston; 61.3 x 32 cm. (134,097).

47. *Salem Cadet Minstrels,*
1897. Color lithograph by Philip Little printed by Forbes Lithographic
Company, Boston; 52.5 x 42.5 cm. (with title). (134,116).

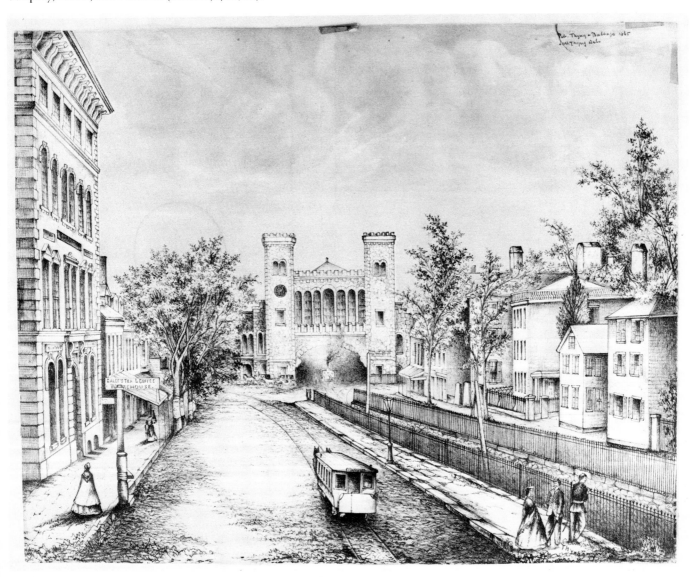

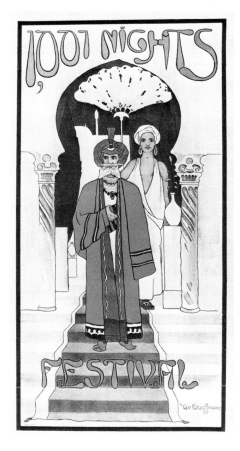

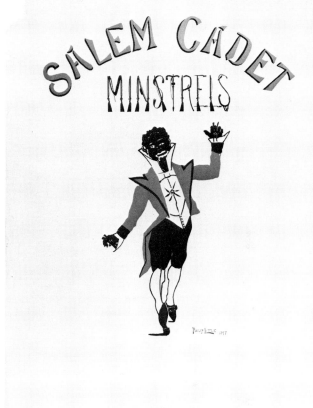

The venture into lithographic printing by the firm of Thyng and Babbidge in Salem in 1865 was short-lived. They published the *Salem Witch* and at least one print, *Lithographic View of Washington Street, Salem, Mass.,* showing the Gothic Revival railway station (*fig. 45*). J. Warren Thyng drew the view on stone, and presumably Babbidge printed it. Within the next three years, J. Warren Thyng disappeared, and William A. Babbidge returned to his job at the *Essex Register.* Their print remains the only nineteenth century lithograph known at this time to be the work of a Salem printer.

Other Salem artists later in the century tried lithography; Joseph Ropes did a little landscape scene, and some anonymous artist did a primitive view of

Newburyport. Even other Essex County artists like Arthur Wesley Dow, painter and etcher, also made a lithograph or two.

Lithography became increasingly flamboyant, as technique in color printing became more widespread, and lithography shops larger and more capable of handling complex printing jobs. Two Salem artists at the end of the nineteenth century drew several images on stone for the Forbes Lithographic Company of Boston, though both men are far better known for their work in other media. George Elmer Browne (1871-1946), contributed a poster design for *1,001 Nights Festival,* and Philip Little (1859-1942), did one for the *Salem Cadet Minstrels,* both dated 1897 (*figs. 46, 47*).

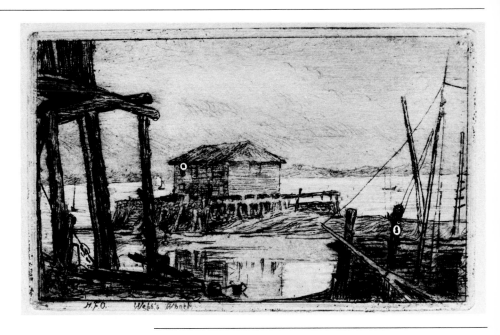

48. *Webb's Wharf,*
ca. 1885. Etching by Harriet Frances Osborne, Salem; 5.7 x 9.4 cm.
(127,108j).

These two men were the first to transmit contemporary art styles to Salem. Browne's *1,001 Nights Festival* used the Art Nouveau style—sensuous black outlines for flattened, simplified, and brightly colored shapes in an overall composition of subtle asymmetry. The style was well suited to the suggestive plot of a young concubine who saved herself from execution by telling stories whose outcomes were postponed to the next night, and the next, until she was spared. Besides the advertising poster for the minstrel show, Philip Little did a black-and-white lithograph of the Minneapolis Flour Mills in the sketchy impressionistic style of the most up-to-date art trends.

Reacting against the flamboyant and sometimes raucous images portrayed in the large and colorful advertising posters of the end of the nineteenth century, some artists turned to a quiet, intimate, smaller, one-color image-making technique called etching. Most artists working in this medium conveyed the delicacy of a summer landscape, a flock of birds, a picturesque dock side.

The Etching Revival came to Salem in 1881 with the help of a little-known woman artist, Harriet Frances Osborne (1846-1913). The guest speaker at the Salem Lyceum Lecture that year was Sylvester Rosa Koehler, first curator of prints at the Boston Museum of Fine Arts. He demonstrated the newly rediscovered skill of fine arts etching with a plate on which Miss Osborne had drawn a little landscape. She subsequently made half a dozen prints, all charming intimate glimpses of the venerable wharves and sea-worn houses of the coastal town of Salem. Around 1886 or 1887 she put together a pamphlet of etchings, similar to work her contemporaries were doing. The gold-lettered packet of oatmeal paper, wrapped in green ribbon, is entitled "Old Salem" and includes five scenes: *Doorway on Federal St.; Junipers, Salem Neck; Custom House from Derby Wharf; Webb's Wharf (fig. 48);* and the *House of Seven Gables.*

One of her contemporaries, George Merwanjee White (1850-1915), also published a book of views, a gold-lettered limited edition *Old Houses and Places of Interest in and about Salem. 1886.* Originally intended as etchings, the plates are heliotypes (late-nineteenth-century photoreproductions) of White's original drawings. Of far more interest are his separately issued etchings of *Light House Winter Island/Salem 1887,* and *Bakers Island Salem Harbor,* as well as etchings of the *Pickering House, Birthplace of Hawthorne, Custom House,* and a plate of the *Essex Institute* buildings (where a number of his prints were offered for sale).

Little notice was made of White's death. Miss Osborne evidently was not considered a noteworthy artist either, though she had taught drawing in Salem for many years. She outlived her immediate family and her death was not even recorded, adding a final touch to her obscurity.

Frank Benson (1862-1951), on the other hand, was known throughout America as a fine etcher and drypoint artist—primarily of wild fowl. His first etching was done in 1882 while he was a student at the Museum of Fine Arts in Boston; the print appeared as frontispiece of the student publication of which Benson was the editor. Benson devoted the next twenty years to painting, not returning to etching till 1915. In the years following he executed a number of prints of ducks in flight, startled by a hunter's blast, or swimming in a marsh. With such national and international figures as Mary Cassatt, Childe Hassam, and John Taylor Arms, Benson participated in the first exhibit of the Brooklyn Society of Etchers in 1916. For the fourteenth annual exhibition in 1930, American art dealers in New York sponsored publication of *Contemporary American Etching,* with biographical sketches of participating artists and photoreproductions of their work. As a frontispiece, Benson contributed an original print, *Startled Ducks.*

Frank W Benson. "to Jane and Gustave Dauenann 1926

49. *Little Bluebills,*
1922. Drypoint by Frank W. Benson, Salem. Inscribed to Jane and
Gustave Baumann, 1926, by the artist; 19.7 x 14.8 cm. (133,845).

A double intimacy of subject and medium are further intensified by a personal inscription on the Institute's fine impression of *Little Bluebills,* a drypoint executed by Benson in 1922, and given by the artist to his friends Jane and Gustave Baumann four years later *(fig. 49).*

Benson was known as the dean of American etchers. In his honor, the Marblehead Arts Association in 1940 arranged a retrospective exhibition of ninety Benson prints, mostly of his famous wild fowl. This marked his twenty-fifth year as an etcher, and called for "a special show of affection from his fellow printmakers." Participants included Samuel Chamberlain, author of the above quote and undoubted instigator of the celebration, and John Taylor Arms, Arthur Heintzelman, Thomas Nason, and the printer Kerr Eby. "For a day at least," Chamberlain declared, "Marblehead became the print center of America."[22]

Chamberlain (1895-1975) himself etched many scenes in Europe and New England. Most households in New England have grown up with calendars and cookbooks illustrated with his photographs, sparkling documents of form and light depicting New England landscape and architecture. *Summer Shadows (fig. 50)* was printed to commemorate the founding of the Friends of Contemporary Prints at the Marblehead Art Association in the King Hooper Mansion, seen at the left in the illustration. This and several other prints of Boston scenes bring the print collection of the Essex Institute grandly to the present day.

50. *Summer Shadows,*
1940. Etching and drypoint by Samuel Chamberlain, Marblehead,
Massachusetts; 21.5 x 27.5 cm. (132,068).

Appendix:
Printmaking techniques

Prints throughout the years have been made from designs most commonly put on wood blocks, copper plates, and slabs of limestone—surfaces which printmakers have found capable of holding ink and transferring it to paper. To understand the techniques represented in the collection, a brief description of the preparation of printing surfaces for each of the major techniques is included here.

A *woodcut* is made by cutting away the surface of a block of wood with metal-headed tools to leave raised areas from which the design is taken. A *wood engraving* is made by cutting the design into the surface of the block. An *engraving* is made similarly, but the design is incised chiefly with a burin into a metal plate, usually copper. An *etching* is made by drawing with a needle-like tool into a thin layer of a resinous substance applied to the surface of a metal plate, thereby exposing areas which, when the plate is immersed in an acid solution, are eaten away to produce an etched line. A *drypoint* is made by scratching directly onto a plate with a heavier needle-like tool, and leaving the burr to catch a denser deposition of ink. This technique is often used with etching, as is *aquatint*, made by dusting onto a plate tiny grains of varnish which, when heated, melt slightly and adhere to the surface. All areas except those of the design are then drawn with a stopping-out varnish, and the exposed areas—tiny spaces between each grain of melted ground, are then etched. *Stipple* is made by drawing either on a bare plate or on a ground with a curved tool and roulette to make a series of small dots. *Mezzotint*, invented to create broad areas of dark tone, is made by incising the entire surface of a plate with a tool with hundreds of points until the desired density is achieved, then polishing away with a scraper areas not meant to print. A *lithograph*, the newest of the mediums represented, is unlike all the foregoing, in that it is printed from a surface essentially flat. The design is drawn onto a prepared slab of Bavarian limestone (later, metal plates would be used) with a greasy crayon or sharp stick. The undrawn areas are then stopped out chemically with a water-based solution which repels grease-based ink.

Plates prepared by these various methods are then inked and printed by presses of different design for each of the major categories of techniques. Printmaking shops sometimes specialized in one technique, sometimes provided the artists and printers to handle several branches of the printing arts.

Footnotes

1. *The Diary of William Bentley, D.D.*, 4 vols. (Salem: Essex Institute, 1914; reprint ed., Gloucester, Mass.: Peter Smith, 1962), 3:53.

2. S[ylvester] R[osa] Koehler, comp. *United States Art Directory and Year Book (Second Year)* (New York, London, and Paris, 1884), p. 147.

3. John W. Reps, "Boston by Bostonians: The Printed Plans and Views of the Colonial City by its Artists, Cartographers, Engravers, and Publishers," *Boston Prints and Printmakers, 1670-1775* (Boston, Mass.: The Colonial Society of Massachusetts, 1973), pp. 33-34.

4. Bettina A. Norton, *Edwin Whitefield: Nineteenth-Century North American Scenery* (Barre, Mass.: Barre Publishing, distributed by Crown Publishers, Inc., 1977), pp. 49, 83, 131.

5. *Saint Joseph Parish, Salem, Mass., 1873-1973* (Salem, Mass.: Published by the Parish, 1973), pp. 1-6.

6. Harry T. Peters, *America on Stone* (Garden City, L.I.: Doubleday, Doran & Co., 1931; reprint. ed., Arno Press Inc., 1976), p. 106.

7. Harriet Silvester Tapley, *Salem Imprints, 1768-1825* (Salem, Mass.: The Essex Institute, 1927), p. 288.

8. "An Inventory of the Estate of Capt. John Crowninshield Late of Salem . . . 1761," *The Crowninshield-Bentley House* (Salem, Mass.: The Essex Institute, 1976), pp. 48-50.

9. *Universal Magazine of Knowledge and Pleasure* (London) 42 (June 1768): 324-26.

10. Andrew Oliver, "Peter Pelham, Sometime Printmaker of Boston," *Boston Prints and Printmakers, 1670-1775*, pp. 133-173.

11. Dumas Malone, ed. *Dictionary of American Biography*, 22 vols. (New York, N.Y.: Charles Scribner's Sons, 1934), 14:565-68.

12. *Diary of William Bentley, D.D.*, 3:348.

13. Sinclair Hitchings, "Thomas Johnston," *Boston Prints and Printmakers, 1670-1775*, p. 120.

14. Philip Chadwick Foster Smith, *A History of the Marine Society at Salem* (Salem, Mass.: The Marine Society at Salem, 1966).

15. Information on Samuel Blyth has kindly been supplied by Nina Fletcher Little, who has been doing additional research on the artist's mezzotints following her article, "The Blyths of Salem: Benjamin, Limner in Crayons and Oil, and Samuel, Painter and Cabinetmaker," *Essex Institute Historical Collections* 108 (1972): 49-52.

16. Thomas Leavitt, "Thomas Leavitt and his artist friend, James Akin," *Granite Monthly* 5(1898):225-34.

17. John J. Currier, *History of Newburyport, Mass, 1764-1909*, 2 vols. (Newburyport, Mass.: Printed for the author, 1909), 2:371.

18. Sinclair Hamilton, *Early American Book Illustrators and Wood Engravers, 1670-1870* (Princeton, N.J.: Princeton University Library, 1958), p. 134.

19. [Benjamin Waterhouse], *Journal of a young man of Massachusetts . . . at Dartmoor Prison*, 2nd ed. (Boston: Printed by Rowe & Hooper, 1816), p. 156.

20. George Cockburn, *Buonaparte's Voyage to St. Helena; Comprising the diary of Rear Admiral Sir George Cockburn, . . . 1815* (Boston, Mass.: Lilly, Wait, Colman, and Holden, 1833), p. vi.

21. Bettina A. Norton, "Tappan and Bradford: Boston Lithographers with Essex County Associations," *Essex Institute Historical Collections* 114(1978): 149-160.

22. Samuel Chamberlain, N.A., *Etched in Sunlight* (Boston: Boston Public Library, 1968), p. 108.